THE LONDON BOROUGH OF
BRENT

ROSAMUND KING & MALCOLM BARRÈS-BAKER

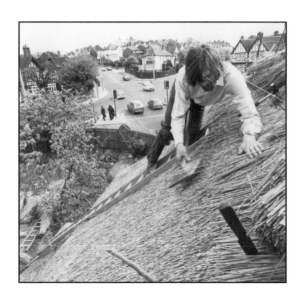

The
History
Press

DEDICATION

To our parents, and to our respective partners, Mr Anthony King and Ms Kirsty McCullagh

Published in association with Brent Council

First published 2011

The History Press
The Mill, Brimscombe Port
Stroud, Gloucestershire, GL5 2QG
www.thehistorypress.co.uk

British Library Cataloguing in Publication Data.
A catalogue record for this book is available from the British Library.

ISBN 978 0 7524 5827 4

Typesetting and origination by The History Press
Printed in Great Britain

CONTENTS

Introduction 5

1 Alperton 7

2 Kenton 15

3 Preston 21

4 Sudbury 27

5 Wembley 35

6 Kingsbury 53

7 Cricklewood 63

8 Harlesden 71

9 Kensal 81

10 Kilburn 89

11 Neasden & Dollis Hill 99

12 Park Royal 107

13 Stonebridge 111

14 Willesden 117

Acknowledgements 128

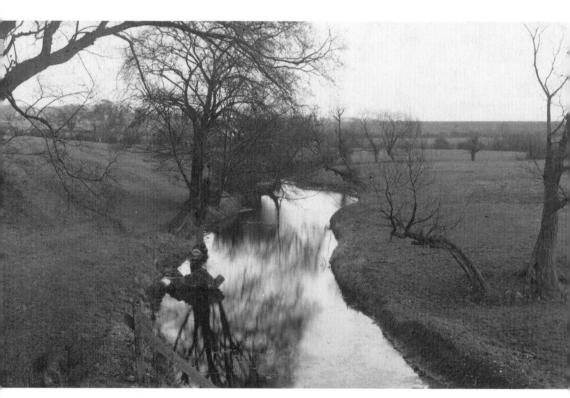

An early twentieth-century postcard showing the River Brent. The river is believed to be named after the goddess Brigantia, making it a rare name of Celtic origin in an area dominated by Anglo-Saxon place-names. The river formed much of the border between the boroughs of Willesden and Wembley, so the name was an ideal choice for councillors trying to unify them when they were merged in 1965. This view looks idyllic, but in the late Victorian period the river was heavily polluted, partly by untreated sewage dumped into it at Wembley. (828)

INTRODUCTION

This book has been written because we think it is time for a new book of old photographs covering the London Borough of Brent as a whole. Although several photograph books covering individual districts of Brent have been published over the past fifteen years, the only work encompassing the entire borough is Len Snow's excellent *Brent: A Pictorial History*, which was published twenty years ago.

Audience development work carried out by Brent Museum and Archives during the past five years has revealed that local people still largely identify with their own areas, rather than with Brent. Hopefully this book will help to rectify this. However, the book is arranged by suburb, rather than thematically, because we recognise that this is how the people of Brent define their identity. Brent, which was created in 1964–5 by combining the former boroughs of Willesden and Wembley, the latter comprising two former urban districts, Wembley and Kingsbury, is an amalgamation of the character and spirit of these various smaller localities, which residents are considerably more familiar with than with the borough itself.

Brent as an entity comes to have meaning when looked at as the sum of its parts and in the context of its various districts, each with its own history. All feed into the story of Brent. Indeed, Brent would not be recognisably Brent if it lacked any one of them!

The creation of Brent and its various predecessors all coincided with periods of enormous change. The urban districts came into existence in 1895, when the south and east of Brent were undergoing massive urbanisation, the boroughs were created in the 1930s, when the north and west were changing from farmland into classic suburbia, and the creation of Brent itself coincided with a period of enormous social transformation.

Forty-five years have passed since Brent was born. Now that the dust has settled from what has not always been an easy union, it is a good time to look back on the past. Brent's motto, 'Forward Together', expresses the spirit in which, as a forward-looking council, it has attempted to meet the challenges of a new century, with rapidly shifting populations and despite three periods of major economic adversity, the last of which is regrettably still with us.

One aim of this book is to increase awareness of the heritage resources open to the public in Brent Archives, and to encourage residents of Brent to make further use of them. All the photographs are taken from Brent Archives' own collections or those of the Wembley History Society, whose holdings were accessioned into the archives in 2010.

While every attempt has been made to contact copyright holders, we apologise for any inadvertent omissions. Copyright holders are invited to contact us, so that we can rectify any such omissions in future editions.

The archives possess a large number of images, ranging from early twentieth-century postcards to recent newspaper photographs. Some 10,000 of these images have been digitised and can be viewed online by visiting the Brent Archives website (www.brent.gov.uk/archives).

The online catalogue numbers of our chosen images are given, in brackets, at the end of the captions. We are, of course, always happy to receive new material.

We have tried to ensure that all of our chosen images are being published here for the first time, or at any rate for the first time since the decade they depict, as clearly some at least of the newspaper photographs have been published once before. Obviously, many of the photographs depict the area before the Borough of Brent came into existence, but many also date from the 1960s and '70s. We have chosen 1984 as a fairly arbitrary cut-off date, partly because our best material predates this and partly because, for one of us, it is hard to think of any photograph postdating the mid-1980s as being in any way 'old'.

We have endeavoured to represent as many aspects as possible of Brent's varied history, but no work of this nature is entirely free from authorial bias. We can only apologise for any apparent concentration on subjects that we find of particular interest.

Needless to say, any errors are ours alone. Any opinions expressed are our own and not necessarily those of the London Borough of Brent.

Rosamund King & Malcolm Barrès-Baker,
April 2011

ONE

ALPERTON

The oldest surviving reference to Alperton dates from 1199. In 1547, Alperton was entirely rural and the largest farm was Manor Farm. It was after this property that Manor Farm Road was named, which is now on the eastern boundary of the current parish of St James.

The construction of the Grand Junction Canal in 1801 was the catalyst for successive development, bringing commercial prosperity to Alperton and even the prospect of barge trips to the Pleasure Boat public house on Ealing Road. There were only twenty-one houses in 1805, rising to forty-one houses and 242 people in 1841.

Trade grew quickly, with little legislation to protect the surrounding area, and Alperton soon became known for poor sanitation. Wembley Urban District Council's Medical Officer of Health concluded in 1896 that the area could never be a salubrious residential neighbourhood because there were factories in central locations, producing oil and manure using rotten fish from London.

The 'King' of Alperton at this time was Henry Haynes (1831–1910), who owned property and businesses and even produced his own token coinage.

Alperton's fast pace of growth was given further impetus by the opening of the railway in 1901. Alperton station, originally called Perivale-Alperton, opened in 1903. Later, in 1932, the London Electric Company began its service (now the Piccadilly Line), using the District Line tracks. As a result, Alperton became a highly populated suburb during the 1920s and '30s, as former farming land attracted more and more industry. The 1950s and '60s saw the arrival of many different communities from around the world, which have contributed to Alperton's more recent economic revival after a period of decline and unemployment. This can be seen in the shops, businesses and cultural activities of Ealing Road, which is now, once again, a thriving thoroughfare.

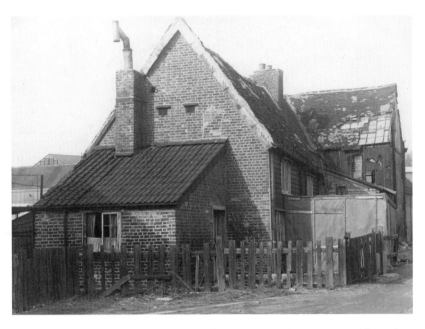

A house dating from the Tudor period (1485–1603). Known as 'the White House', it was situated south of the railway viaduct on the south side of the High Street. When it was demolished in 1955, a Charles II farthing from 1672 and an eighteenth-century Georgian halfpenny were found beneath the floorboards by the door. Part of the Wembley History Society Collection, this photograph captures a glimpse of a vanishing rural world. (9347)

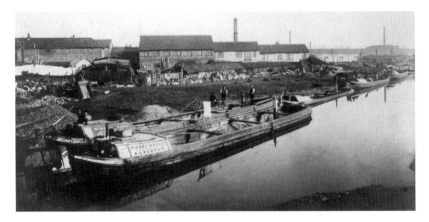

Alperton Wharf in the late nineteenth or early twentieth century. The coming of the canal about a century before had had an immediate effect on trade. Late nineteenth-century Alperton was the most industrialised village in the Wembley area and threatened to become 'the dusthole of the Metropolis', but the decline of its brickfields and, perhaps, the creation of Wembley Urban District Council, had led to an improvement by 1896. One of the narrowboats in the photograph belongs to Harry Haynes, the son of leading Alperton citizen Henry Haynes. Harry became a Wembley councillor in 1894. (8876)

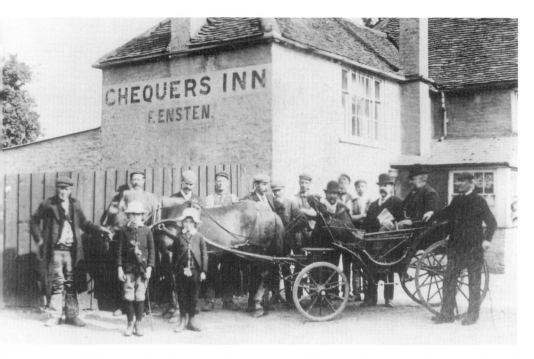

Here we see the old Chequers Inn, Alperton, which was licensed from as early as 1751. This image belonged to the granddaughter of Henry Haynes, the famous local builder who was Alperton's main employer and also the owner of most of its buildings. He ran a brickworks and provided the funds for shops, a church, housing and the Alperton Park Hotel, where he also lived from 1866. The Chequers was rebuilt in 1903, but was demolished in 2011 and replaced by a new building comprising thirty-two self-contained flats and two retail units. (8906)

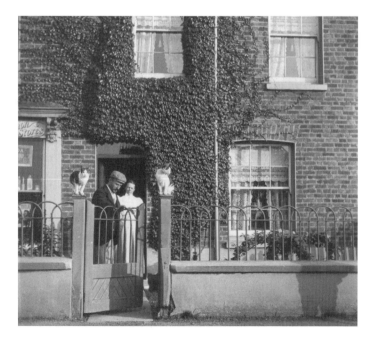

Mr Chambers, a local contractor, his wife and their cats outside their terraced house, near the canal at Alperton. The buildings were blitzed during the Second World War. Note the shop to the left. (8901)

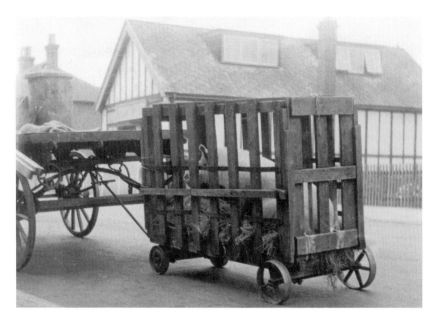

A pig in a wheeled pen being towed by cart through Alperton. In the late nineteenth century Alperton was unfairly known for its offensive smells, which were produced by a sewage farm, two recycling plants producing manure and three large piggeries. The combination of these gave Alperton rather a squalid reputation. This photograph was also donated to Brent Archives by the granddaughter of Alperton's most famous resident, Henry Haynes. (8887)

Stanley Parade, Ealing Road, in the early twentieth century. This view is looking north, with the modern entrances to Haynes Road and Clayton Avenues somewhere behind the photographer to the right. Stanley Parade corresponds to nos 111–41 Ealing Road. During the First World War, John F. Douglas, the vicar of Alperton, housed four families of Belgian refugees, comprising thirteen individuals, in a shop called The Bonnet Box at no. 10 Stanley Parade. This postcard was produced by H.G. Stone of Slough, Berkshire. (8995)

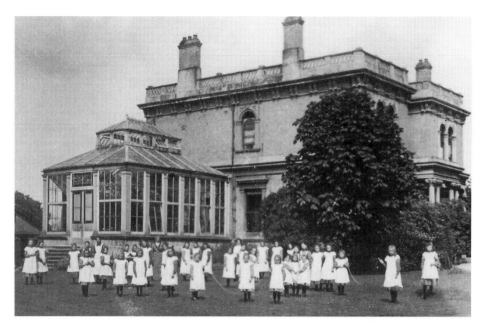

Alperton Hall as the Imperial Yeomanry School for Girls, 1914. Alperton Hall was built in about 1885 and housed the Imperial Yeomanry School from 1904. The school had been created to educate the orphaned daughters of volunteer mounted infantry killed in the Second Boer War. It later took their sons also. These girls are probably mainly the orphans of men in the second contingent of Imperial Yeomanry, sent to South Africa in 1901. This contingent contained a lot of married men, who had initially been discouraged from joining. In 1921 Middlesex County Council purchased Alperton Hall, opening Wembley County School there in January 1922. The building was demolished in 1939. (8907)

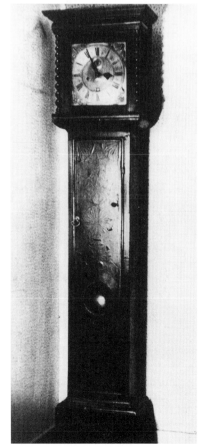

A longcase clock from the original Plough Inn. The Plough was licensed from 1722 and in the hands of the Haynes family for much of the nineteenth century. It was rebuilt in 1936–7, temporarily changed its name in the 1980s and was connected with Brent's Polish community in the late 2000s. This image shows the clock after it had been removed from the pub. The original caption called it a '400-year-old grandfather clock', but longcase clocks like this did not exist until the later seventeenth century. (9356)

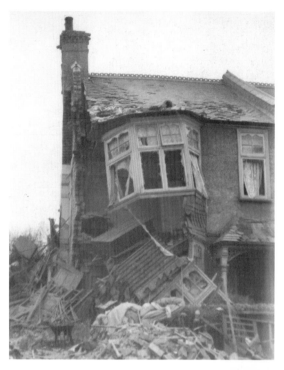

Second World War bomb damage to 19 Clayton Avenue. Both this house and no. 17, which, judging from this postcard, appears to have been almost completely destroyed, were rebuilt after the war. Today they look no different to their neighbours. The resident of no. 17 in 1937 still lived there in 1955, and the resident of no. 19 is not listed among Wembley's civilian war casualties. (2664)

An employee of the Glacier Metal Company, probably sometime in the 1960s, photographed by Anthony Barthorpe. Glacier Metals was founded in 1899 for the manufacture of anti-friction metals. During the First World War, their business turned to war work. It grew considerably between 1921 and 1935, when it went public. After the Second World War Glacier established or acquired other factories outside Alperton. In the post-war years, they conducted a lot of research into management/worker relationships and established their own management institute in Ruislip. They also introduced sophisticated production methods, which enabled them to become one of the world's foremost manufacturers of plain bearings. In 1964, they became the Bearing Division of Associated Engineering Limited, in a merger which allowed them to retain considerable autonomy. Glacier Metals took

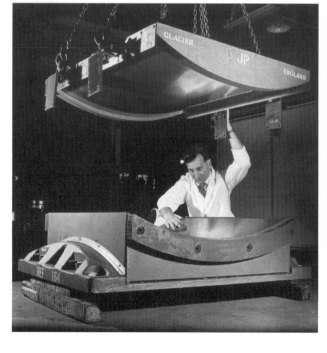

advantage of the mood of the 1960s with an effective promotional film called *Investment in Technology*, which conveyed an impression of reliability, combined with a modern outlook, and which offered potential customers access to the latest advances in technology of the day. (8808)

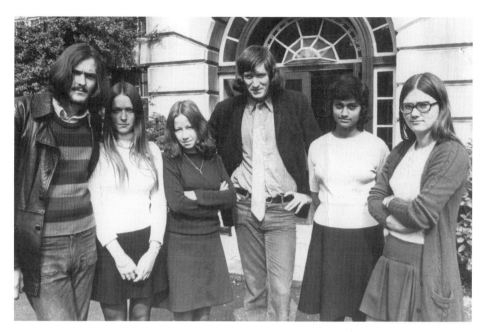

Alperton High School sixth formers in the early 1970s. The original caption reads: 'Some of the 6th formers left to right are; Simone Smith, Valerie Adnett, Sherry Muneer and Christine Williams, who helped at Leavesden Hospital, with ex-pupil Stephen Smith (left), chairman of the 6th Form Charity Committee and J.V. Hardy a teacher at the school (centre).' (9004)

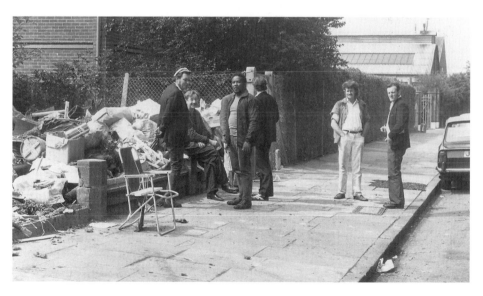

Strikers from Brent manning the picket line in a dustbin-men's dispute in August 1973. The cessation of rubbish collections in the area led to concerns about safety and the spread of disease, as rubbish piled up around the borough. With the benefit of hindsight, it might be seen now as a foretaste of the unpleasantness of the 'Winter of Discontent' of 1979, which helped bring down James Callaghan's Labour Government. (9354)

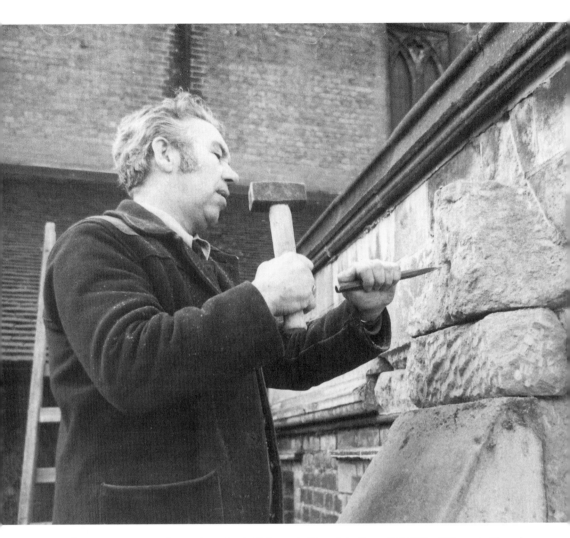

A stonemason carrying out repairs to St James's Church in the mid-1970s. St James's Church began its ministry in Alperton in 1912. A broken pillar was identified in June 1975 and the whole structure of the church was in danger. The repairs clearly failed, as the old church closed on 15 January 1989. A new building opened on Stanley Avenue on 23 June 1990. St James's is an example of the many churches in Brent that have coped with an ever-changing local environment and of a parish which has tried to reach out to many of the area's newer communities, not just by physically rebuilding but by renewing itself to meet the needs of a changing congregation. (9353)

TWO

KENTON

K enton is situated in the north-west of Brent, bordering Harrow. The name Kenton probably comes from 'farm of the sons of Coena', a local Saxon tribesman.

The Old Plough was the only inn in Kenton until 1873, when a beer shop appeared near the railway. The London to Birmingham railway cut through the lands belonging to Sheepcote Farm in 1837, but no station was then provided. Most people worked in agriculture at this time.

The first suburban buildings in the area were railway cottages. In 1912 a new local landowner, Captain E.G. Spencer Churchill (1876–1964), a relative of Winston Churchill, bought Sheepcote Farm and intended to develop a new suburban estate for a high class of resident, called Northwick Park. After the First World War Spencer-Churchill's grandiose plans were watered down, the land split up and less expensive houses built.

The opening of the Metropolitan Line station in 1923, the British Empire Exhibition at Wembley in 1924–5 and general road improvements led to unprecedented growth in Kenton – from a population of 300 in 1921 to 6,000 in 1931. A shopping centre began to emerge from 1924.

In the thirteen years after 1925, Kenton was irrevocably altered from a small village into a large suburban area. South Kenton station was added in 1933 and, by 1938, all traces of the former charmingly rural village were removed, although it still retained the name.

The new suburb of Kenton was divided between local authorities. From 1934, the southern part was administered by Wembley Urban District (Wembley Borough from 1937) and the northern part was run by Harrow Urban District.

Northwick Park Golf Club, a relic of Captain Spencer-Churchill's grand plans, was finally demolished in the 1950s. The new Northwick Park Hospital replaced it in 1970, but part of the old golf course still remains as open space today.

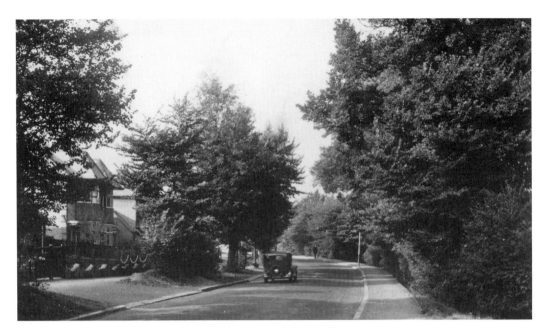

Woodcock Hill between the world wars. The numerous trees and largely empty road on this postcard sum up much of the appeal of inter-war suburban living. The houses in this area, which was less than thirty minutes by rail from Euston, were largely built by F. & C. Costin between 1931 and 1937. (1343)

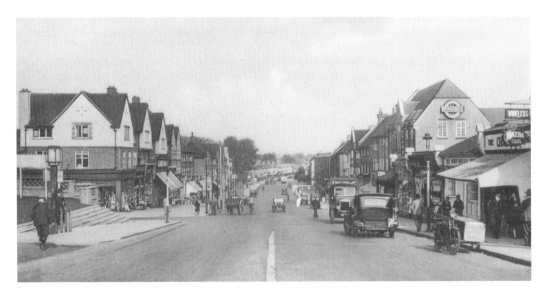

Kenton Road, looking east from the station, probably in about 1933. The Brent/Harrow border runs down the middle of the road. Kenton station, behind the photographer to the right, opened in 1912. The shopping centre began to develop from 1924, with the distinctive row of small coal merchants' shops in the right foreground appearing between 1927 and 1930. They were demolished in the late 1990s, when Sainsbury's was built. A large lamp belonging to the Rest pub, from 1933 the largest pub in Middlesex, can be seen on the Harrow side. (7878)

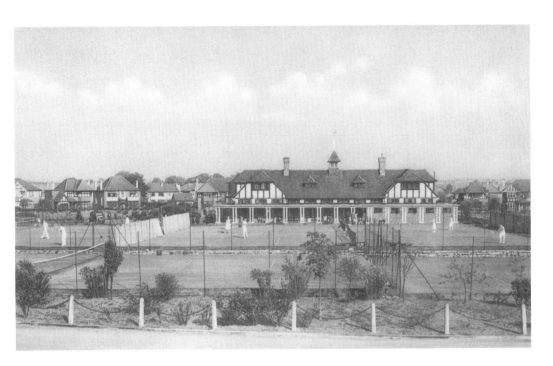

The Palaestra, Northwick Circle, probably in the early 1930s. From 1912, Captain Edward George Spencer-Churchill, Lord of the Manor of Harrow, planned to develop an estate in Kenton, named Northwick Park after his country seat in Gloucestershire. The centre of the development was to be a tennis and social club. The Palaestra was built by Northwick Park Tennis Club in 1923, with houses built by Cramb Bros of Finchley and, later, Costins, following in the 1920s and '30s. In October 1954 Harrow District Masonic Association took over the building, having previously considered the late 1930s Herga Cinema in Wealdstone. (7874)

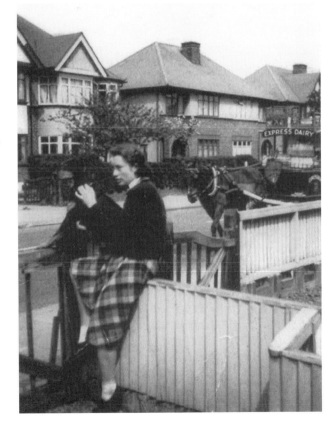

Preston Hill, Kenton, *c.* 1954. Here we see Miss Angela Berry, with her pet dog, outside 69 Preston Hill, Kenton. The house was built in the late 1930s by Comben & Wakeling, and is part of the Lindsay Park Estate. Note the horse-drawn Express Dairy milk cart to the right. (7827)

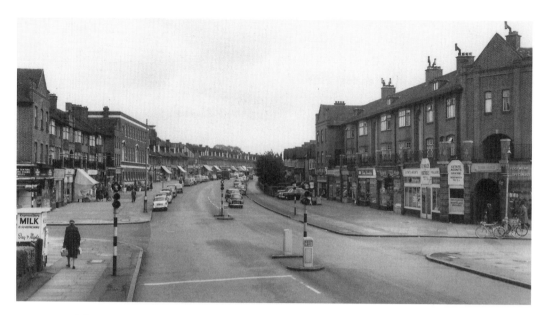

Kenton Road, looking east at the junction with Kenton Lane (left) and Woodcock Hill (right). The block to the right is Devon Parade, with the maisonettes of Devon Mansions above the shops. The block to the left is Kenton Park Parade, in Harrow. Note that what looks like an Express Dairy milk dispenser can be seen to the extreme left. (8770)

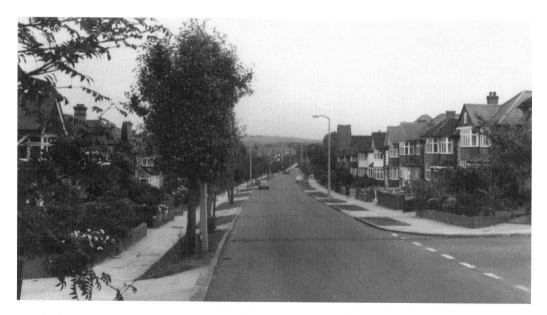

Woodcock Hill in the late 1950s or early 1960s. The church tower in the middle distance to the right of the road belongs to St John's United Reformed Church. Nearby Woodcock Park, which opened to the public in 1952, formed part of the grounds of Kenton Grange, built in 1803–7. Surprisingly long-lived 'prefab' housing was erected in nearby Tenterden Close after the Second World War. These 'prefabs', viewed with affection by many residents, remained until the 1960s. (8762)

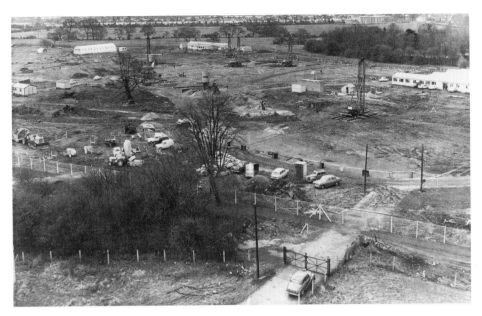

The western part of Northwick Park, where work was commencing on the first stage of the £13 million Northwick Hospital and Medical Research Centre. This photograph was published in the *Wembley News* of 15 April 1966, p. 16. The hospital opened in 1970. (9266)

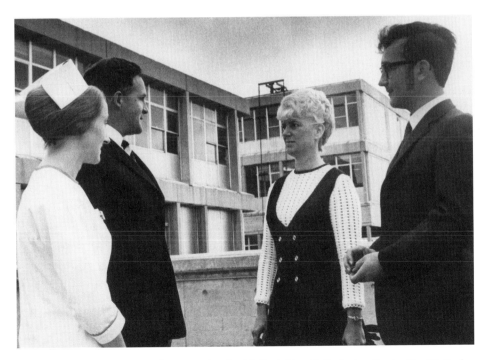

Sister Wade and Cllr Hart welcoming Northwick Park Hospital's first patients, Mrs M. Taylor and Mr J. Christie, 1970. (8964)

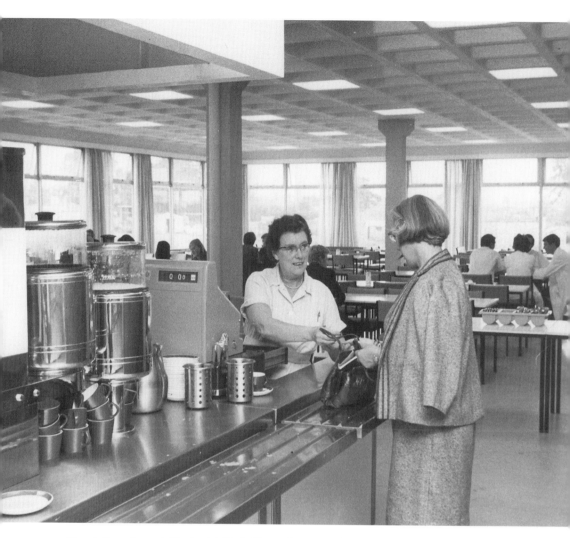

The staff canteen at Northwick Park Hospital, 1970. This *Wembley News* photograph shows the self-service canteen shortly after the hospital opened. (8965)

THREE

PRESTON

Preston is situated on the western side of Brent, north of Wembley and south of Kingsbury and Kenton. Its name means 'priest's farm' and it began as a small settlement at what was known as Preston Green, just south-west of the Lidding (later Wealdstone) Brook. The name may have originated from an estate granted to Abbot Stidberht by King Offa of Mercia in AD 767, but any connection with the Church had ended by 1086, when the Domesday Book was compiled.

Preston is also linked with Uxendon, an even smaller settlement on the east bank of the Wealdstone Brook and the western slopes of Barn Hill. In the mid-nineteenth century Uxendon was used for steeplechases.

By the mid-fifteenth century, the northern farm at Preston belonged to the Lyon family. Perhaps the most famous resident of Preston was John Lyon (1534–92), who lived on what is now Preston Hill, and who not only founded Harrow School in 1572, but gave property for its upkeep and, by bequest, provided for the upkeep and repair of Edgware and Harrow Roads.

Preston's early history was closely bound up with the fortunes of the Bellamy family, who resided at Uxendon Manor and who were arrested for treason in the Babington Plot of 1586 against the Protestant Government of Elizabeth I.

As a result of these events, the Bellamys' land had passed to the Page family by 1608. The Pages continued the process of enclosure begun by their predecessors and this was responsible for the transition from arable to meadow farming in the eighteenth century.

A proposed station for Preston was rejected in 1896, because the area was not populous enough. However, by 1900, Uxendon Farm had become the location of a shooting ground. When the Olympic Games were held in London in 1908, the ground was chosen for clay pigeon shooting, and this led the Metropolitan Railway to open Preston Road Halt on 21 May 1908. The halt stimulated the first commuter development in the district, and ultimately led to the opening of a proper, slightly resited, station in 1931.

Even in the early twentieth century the area was entirely rural. Preston Road remained little more than a country lane until the late 1930s. Suburban development came after the 1924–5 British Empire Exhibition and associated road works. Housing spread along Preston Road and Preston Hill in the 1920s, accompanied by a pub, the Preston Park Hotel.

Most housing development occurred in the 1930s and numbers of Jewish people came to Preston in the same decade. Many shops had appeared around the station by 1936–8. By 1951 Preston boasted a population of 12,408, though it later declined. By the early 1960s, all of Preston's oldest buildings had gone. Yet, despite the inevitable loss of some of its earlier character, Preston still retained much of the atmosphere that had made it so desirable to home-buyers between the wars.

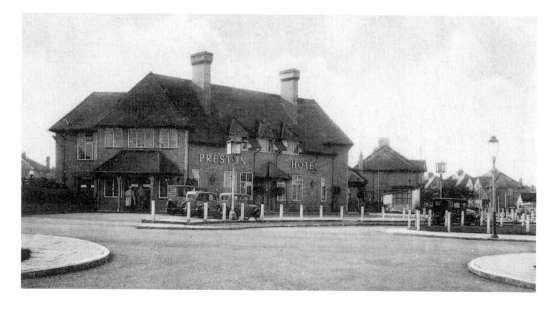

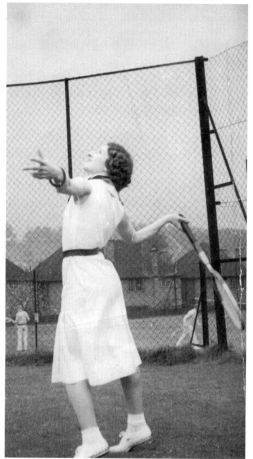

Above: A coloured postcard of the Preston Park Hotel, sometime between 1927 and 1935. Built in the style of a large road house, the Preston Hotel, now simply called the Preston, dates from the late 1920s and is now a public house run by the Ember Inns chain. (1680)

Left: Marjorie Hood playing tennis at Preston Road Tennis Club in the 1930s. Marjorie would later marry Stanley Cox, a fellow member, but she did not know him when this photograph was taken. (2674)

Opposite, top: An aerial photograph of Preston Manor County School taken by Aero Pictorial Limited on 2 June 1939. The school had opened the year before. The playing fields in the background are now Forty Farm Sports Ground. (©English Heritage. NMR Aerofilms Collection)

Opposite, bottom: The construction of the Preston Estate at Lindsay Drive in 1947 or 1948. A bridge over the Wealdstone, or Lidding, Brook, can be seen. The plan required three crossings of the brook, two to allow a roundabout to be placed over the brook and one to cross it further north, at Falcon Way. This is the more northerly of the two roundabout bridges. This photograph was taken by Wembley's Borough Engineer and Surveyor's department. Note the army surplus jeep, presumably belonging to a contractor. (3771)

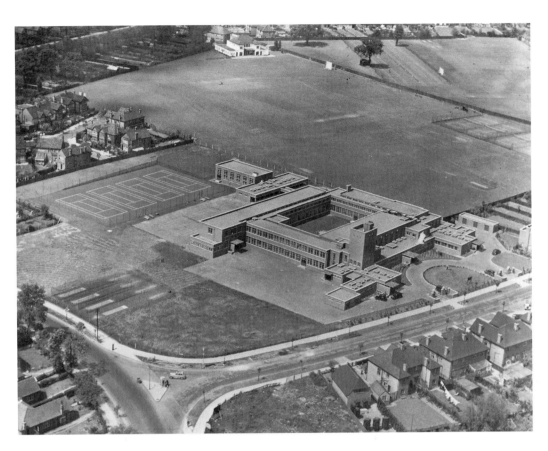

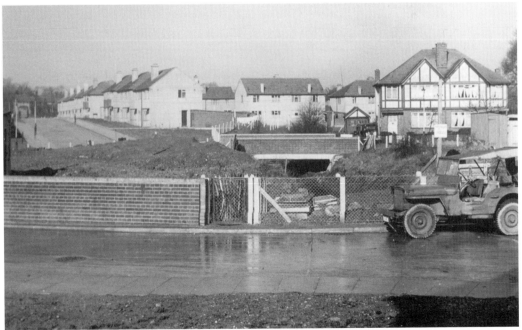

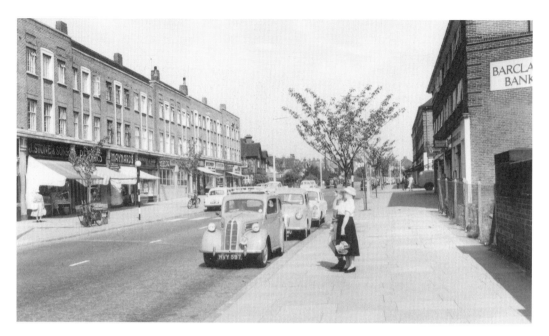

Preston Road, Preston, in the late 1950s, looking north from the railway bridge. Barclays Bank is still there. (8631)

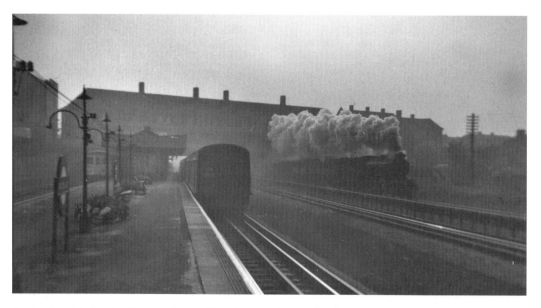

Preston Road station, looking south-east. This photograph was taken by young trainspotter Tony Travis on the early morning of Sunday 14 October 1962. He was using 127 roll film in an old 1930s Exacta camera that his father had purchased for him in 1958. Two London Transport Metropolitan Line trains come and go, while a special steam train of the Locomotive Club of Great Britain races by on British Railways tracks. Contrary to the modern view of railway photography and spotting, in this period it was frequently the hobby of middle class and/or academically able boys. Tony went on to become a successful historian of science. (8489)

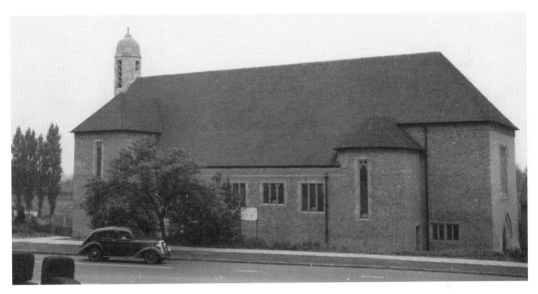

The Church of the Ascension, Preston Road, in the late 1950s or early 1960s. Preston became an Anglican parish in 1951 but the church was not consecrated until 1957. (8641)

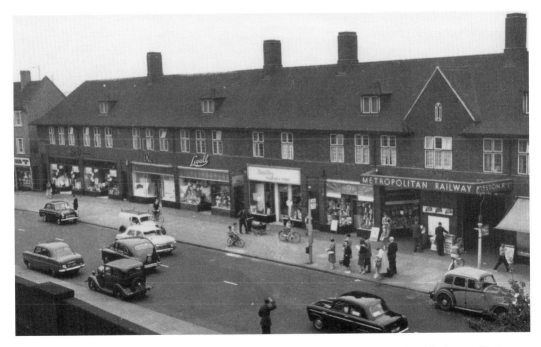

Preston Road shops near the station, probably in the late 1950s. A branch of Sketchley's, Ligall's drapers and wool retailers, Rex, a ladies' hairdressers, and Boyd Limited, who sold radios and televisions, can all be seen. Today, the Sketchley's premises has become a kebab shop, Ligall is Petal Greeting Cards and Gifts and Boyd's may be familiar to residents as Opticalise Ophthalmic Opticians. Only Rex has survived unchanged, even down to retaining its original signage. The shop just to the left of the station, as you look at the photograph, is currently empty. (8636)

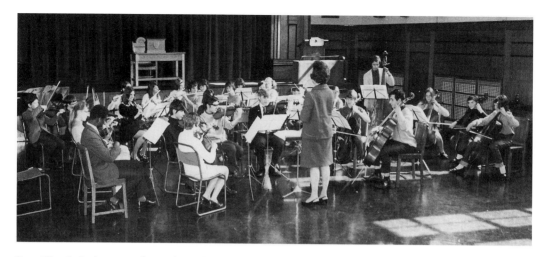

Brent Youth Orchestra auditions being held at Preston Manor School, probably in the 1970s. The orchestra was set up in 1970 by Muriel Blackwell, the Borough's Musical Advisor. On their tenth anniversary, a work was especially commissioned for them from the Master of the Queen's Music, Australian composer Malcolm Williamson (1931–2003). The piece, Williamson's twenty-four-minute-long Fifth Symphony 'Aquerò', based on the life of St Bernadette of Lourdes, premiered at Brent Town Hall on 23 April 1980 and was then performed again on tour in Sweden. (8946)

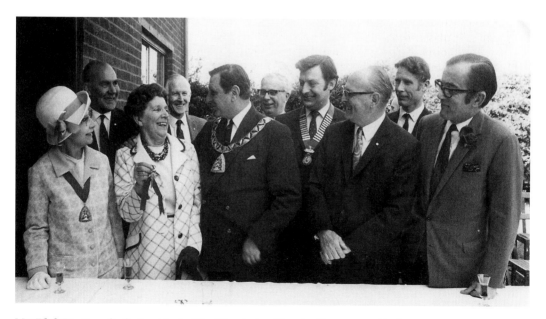

Mrs Edith Banting, the first resident of the Silverholme Housing Project, an elderly persons' accommodation situated on Woodcock Hill. She is seen receiving the key to her flat from Cllr Dennis Jackson, the Mayor of Brent, on 8 May 1971. The rest of the group consists of the Deputy Mayor, Alderwoman Mrs Edith Lewis; Mr Alistair Fisher, President of Alperton Rotary Club; Mr E.H. Blinhorn, Chairman of the Silverholme Housing Association; Mr Arthur Edmond, Vice Chairman of Silverholme; Mr Les Wallis, Chairman of the Wembley Round Table and Mr George Willcox, the President of the Wembley Rotary Club. (9205)

FOUR

SUDBURY

The name Sudbury first appears in 1273–4 and indicates that it was the southernmost of Harrow's two manors. Sudbury was the Archbishop of Canterbury's main Middlesex residence until the end of the fourteenth century. Sheep farming was important in the area.

In the late sixteenth century, John Lyon, founder of Harrow School, made a road from Harrow to London. This road spurred development in the two centuries that followed. The number of new farmhouses in the seventeenth and eighteenth centuries reflected agricultural prosperity, but local farmers, including the novelist Anthony Trollope's father Thomas, suffered heavily in the agricultural depressions of the 1820s and '30s.

The opening of Sudbury (now Wembley Central) railway station in 1842, along with horse bus services three years later, gave a further push towards development. Sudbury was the first part of the Wembley area to show significant growth, and in the mid-nineteenth century was generally seen as more important than Wembley itself. In 1861 it had a population of 813, while Wembley's only reached 444 ten years later. It is no accident that St John's Church, Wembley, is close to Sudbury.

Four more railway stations opened in the 1900s, followed by electric tram services in 1910. The 1924–5 British Empire Exhibition, and the new bus routes it created, also encouraged suburbanisation.

The United Dairies milk depot at Hundred Elms Farm, Perrin Road, 1951. The farm had become a dairy before 1862. The red brick outbuilding with the mullioned windows in the centre of this photograph was probably built in the 1540s. In the past some believed it to have been a chapel, or even 'a portion of an old nunnery' (*Wembley Official Guide*, 1933), but it is far more likely to have been a secular structure, perhaps part of the large house called Sudbury Place. Today it is once again residential accommodation. (9327)

Chester Vaughan Series postcard showing the Swan public house on the Harrow Road. The Swan had existed from at least 1786, but had been rebuilt, probably in the early 1890s, following a fire. This view must date from before 1910, when the street outside the Swan became a tram terminus, and probably postdates 1902, when postcards like this, with the image filling the front and the address and message sharing the back, were introduced. (9608)

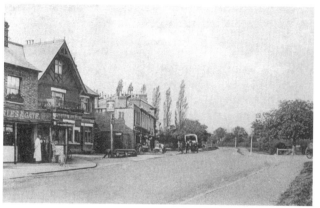

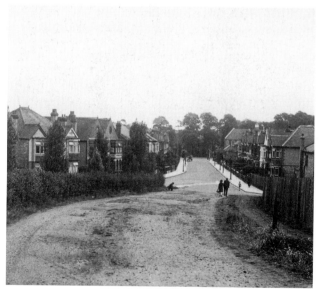

An inter-war view of District Road, taken from Bridge Approach, today Allendale Road, which at that time still looked quite rural. The turn-off to the right is Station Crescent and Sudbury Baptist Church can be seen in the distance. District and Central Roads were built between 1907 and 1910 and take their names from the railway companies serving Sudbury's four railway stations, the District Railway (Sudbury Town and Sudbury Hill) and the Great Central (Sudbury & Harrow Road and South Harrow, today's Sudbury Hill, Harrow). At the same time, in 1907, some shops (Sudbury Parade) were built south of the Great Central, opposite the present Barham Park. (853)

A mulberry tree in front of Crabs House, on the Harrow Road. The house was built during the reign of George III and took its name from the family who lived there in the 1790s. It was also later referred to as Old Court. After James Crab it belonged successively to John Copland, his daughters Frances and Anne, General Robert Copland-Crawford and Sir George Barham, the founder of Express Dairies. (9707)

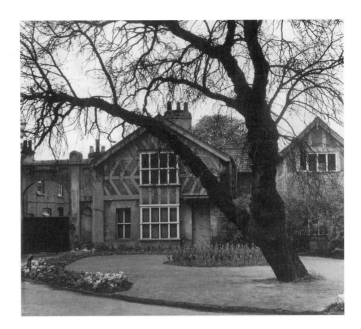

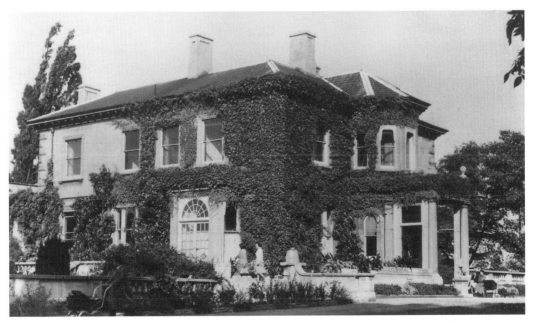

After their father's death in 1843, Frances and Anne Copland built a new house, called Sudbury Lodge, just north-east of Old Court. On General Copland-Crawford's death (his ghost is supposed to haunt the park to this day) the estate was sold to George Barham, who had lived at Crabs House since about 1880. Sudbury Lodge was renamed Barham House. Barham's son, Titus, who had lived at Old Court once his father had moved to the main house, inherited the estate on Sir George's death in 1913. Titus did much to beautify the grounds before his death in 1937. During the Second World War Barham House was used by Civil Defence personnel. It became neglected, and was finally demolished by Wembley Council in 1956–7. (9593)

As well as being a Wembley councillor for three years in the 1930s, Titus Barham was an active member of Wembley Horticultural Society and held 'Rose Sundays', when he opened the gardens of his house to the public. When he died in 1937, on the eve of becoming Wembley's first mayor, he left the estate 'for the benefit and use of the citizens of Wembley'. In January 1938 the council instructed the Borough Engineer 'to arrange for the erection of . . . notices in a conspicuous position informing the public that the grounds of Sudbury Park are open for their use and enjoyment.' A month later it was renamed Barham Park. (8937)

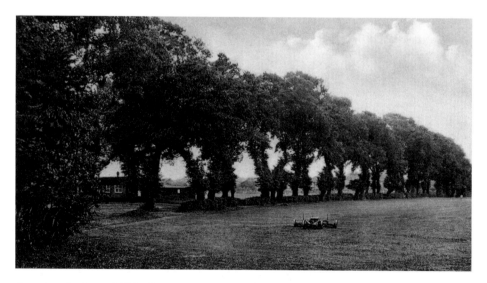

A postcard view of Vale Farm Sports Ground, taken between 1928 and 1950. In the inter-war years, local farms sold off their land, though a few open spaces survived. Part of the holdings of Vale Farm were turned into playing fields in 1928. The idea of a sports centre at Vale Farm first surfaced in 1959. However, the project was shelved several times owing to lack of funds. A running track was completed in 1968, but the official opening did not occur until 25 May 1975. Vale Farm's tenth anniversary was marked with a carnival of sport in July 1985. (9603)

The William Perkin memorial seat, 1966. The bench commemorated Dr (later Sir) William Perkin (1838–1907), a chemist and dye manufacturer famous for having invented the colour mauve in 1856. This was the world's first synthetic dye and was popularised when worn by both Queen Victoria and the Empress Eugénie. In 1873, Perkin built a house in Sudbury called the Chestnuts. Perkin's memorial bench was unveiled by the eldest Miss Perkin on 12 August 1939, opposite his home in Harrow Road. (9319)

A street scene showing nos 800–8 Harrow Road, probably in 1963 or 1964. Andrea Shaw's fashion shop is listed in the 1965 *Curley's Directory of Wembley*, but not in the 1962 edition. Arthur Green's hairdressing salon is in the 1962 edition, but not the 1965 one. The type of shop found here has clearly changed a lot, and much of this parade now consists of fast food outlets. Andrea Shaw's is now a KFC Xpress. Today, Arthur Green's is Sudbury Drycleaners, while Royal London Insurance has become an estate agent's premises. (372)

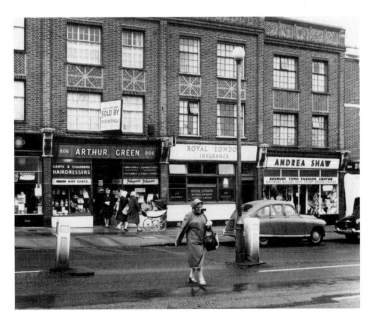

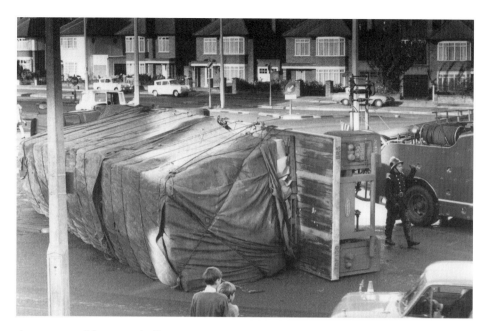

An overturned lorry on Sudbury Court Drive in the 1960s. The road signage and multiple concrete lampposts are already a long way from the *rus in urbe* dream that attracted people to the suburban houses on the far side of the road three or so decades earlier. (9360)

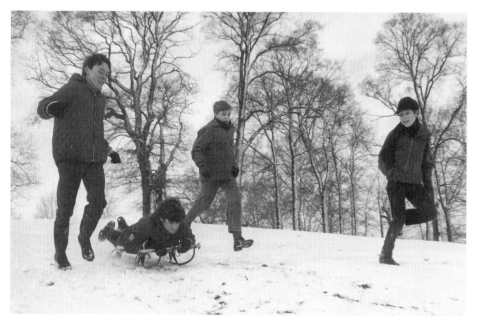

A *Wembley News* photograph showing a snow scene with children playing at Elmwood Park, near the Sudbury Court Estate, March 1970. Elmwood Park is a small area of grassland in Brent with no formal facilities, and the children were clearly having to make their own seasonal entertainment. (9346)

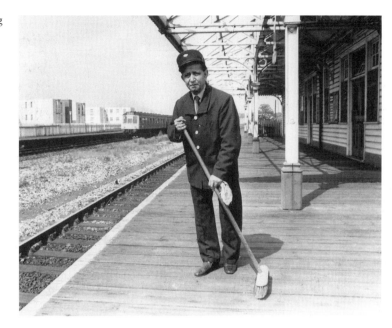

Mohammed Saddiq working at Sudbury & Harrow Road station, summer 1973. When a television programme was made about the station, it was discovered that Mr Saddiq had been a famous singer in India, reputedly on a par with Cliff Richard in the UK. Mr Saddiq was fifty-seven and lived in Acton with his wife and daughter. The station has since been demolished and rebuilt with the platforms between the tracks. It is currently unstaffed. (9844)

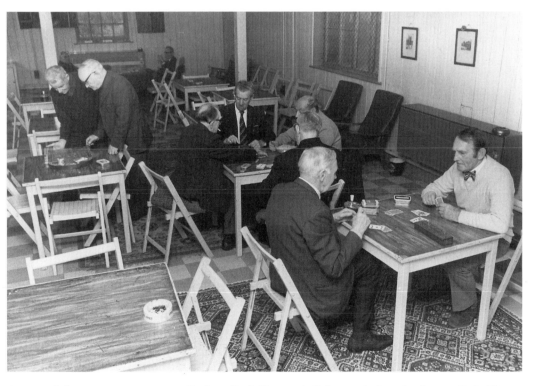

A view of the new games room at Barham Park Veterans' Club, attached to the former Crabs House. This photograph appears to date from the 1970s, when veterans of both world wars would have been members. Traditional pub games such as cribbage and shove ha'penny are being played, and many of the members clearly roll their own cigarettes. (9331)

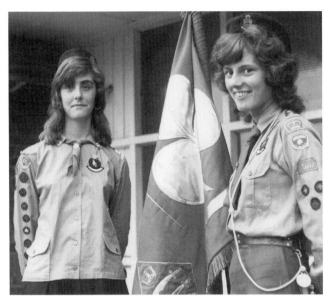

Sudbury Guides Brenda Lacey and Jane Sands, two Queen's Guides of the 2nd Sudbury Group, in the 1970s. The Queen's Guide award is the highest attainable award for members of the Guiding Movement. Although originally awarded to Guides, it is now only obtainable by members of the Senior Section, i.e. those training to run their own Guide companies or Brownie packs. It is a programme of self-challenge comparable to the Gold Duke of Edinburgh's Award. Since the awards were created sixty years ago, 20,000 young women have gained the accolade. The syllabus must be completed within three years, and before the Guide's twenty-sixth birthday, and must include a residential experience, an outdoor challenge and community action. (9708)

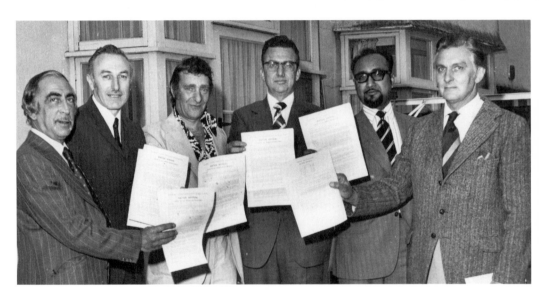

The 'Sudbury Six' rate protesters, holding their rates appeal leaflets. From left: Mr Myers, Mr Williams, Mr Barmul, Mr Fiegel, Mr Natthoo and Mr Maskell. (2787)

FIVE

WEMBLEY

The first reference to Wembley was in the ninth century, as 'wemba lea'. The name means Wemba's forest clearing and is thought to have derived from a nickname using the Old English word 'wamb' meaning belly. Wembley originally belonged to the Manor of Harrow and the settlement of Wembley had its origin on Wembley Hill.

Development and population growth were slow; there were two dwellings paying tithes in 1316, but still only six houses recorded in 1547. Until the twentieth century, Wembley was subordinate to more prosperous Sudbury, and also dependent on it for water from its wells.

The parish church of St John was built in 1845, close to Wembley's principal benefactors, the Copland family, who lived in the present Barham Park. The main farmhouse, Oakington Manor Farm, was on the other side of modern Wembley. It was the home of Sir Patrick Talbot (the son-in-law of the Prime Minister, the Earl of Derby), from 1862 to 1883. Like the Coplands, Talbot was active in Wembley affairs.

The coming of the London to Birmingham railway began to alter the character of the area, although the station, opened in 1844, was originally called Sudbury, rather than Wembley, reflecting their relative significance. The Railway Hotel existed by 1877, and there were shops by 1882. Further expansion continued in the 1890s and the Great Central Railway opened a station at Wembley Hill in 1906, which, though not the main cause of development, prompted more building work south of the emerging High Road.

Prior to the nineteenth century, much land at Wembley had been owned by the Page family, whose seat was the future Wembley Park Mansion. In 1792 Richard Page hired Humphry Repton to restyle and landscape his property. The result of this work was the original 'Wembly Park'. This park was acquired by the Metropolitan Railway in 1889 and turned into a recreation ground. As well as cricket pitches, a running track and a boating lake, the park boasted the first level of a near replica of the Eiffel Tower.

Wembley's fortunes were promoted when it was chosen for the site of the British Empire Exhibition, which took place during 1924–5 and was successful in terms of visitor numbers (27 million saw it over the two years), though it did not break even. Even before the exhibition, the new Empire Stadium was in the news as the venue for the 1923 FA Cup final. The exhibition has been said to have put Wembley 'on the map'. Many local roads were widened and straightened to allow access for new bus services, and the growing numbers of cars. Visitors were impressed by Wembley's rural surroundings, and people moved out to live in new suburban estates which swallowed up the countryside that had attracted them in the first place. Wembley's population

underwent an explosion, climbing from 203 inhabitants in 1851 to 4,500 in 1901, and 48,500 by 1931.

Wembley High Road suffered a steady decline from the 1970s onwards and many shops closed down. However, more recently, effort has concentrated on the regeneration of the area through station improvements at Wembley Park and the redevelopment of Wembley Stadium, which will play a part in the 2012 Olympics, as it did in the 1948 games. The old Wembley, with its iconic twin towers, was demolished in 2003 and replaced by a new stadium the arch of which is visible for miles, especially when illuminated at night. The stadium continues to host the FA Cup final and other major sporting and musical events.

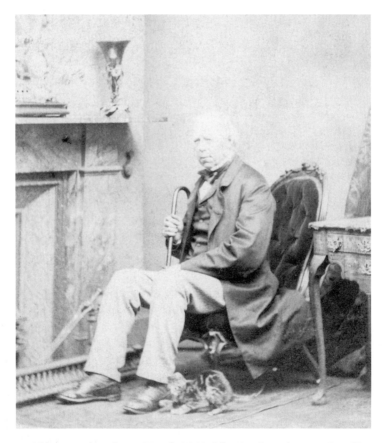

Local farmer John Edmund Read, 1868. John Read was born at Wembley Hill Farm in 1795. His father, John Henry Read (1751–1823), had lived at West Lodge, Enfield Chase. The Reads were a famous farming family of Wembley and were tenants of the dominant local landowners, the Pages. The Reads are well-documented in their own records, now in Brent Archives, which detail their life in Wembley from the end of the eighteenth century until another John Read emigrated with his family to Australia in 1922. The photograph was donated to the Wembley History Society by a Miss Read. (9455)

Boxing dogs at Wembley Park, Whit Monday, 1898. The 216-acre park had officially opened in May 1894, though an Old Westminster v Cambridge University cricket match had been played there on 10 February 1894. The park boasted a water chute, which can be seen in the background here. The Whit bank holiday was one of the bank holidays introduced by Liberal politician Sir John Lubbock's Bank Holidays Act in 1871. In 1898 it fell on 30 May. (9672)

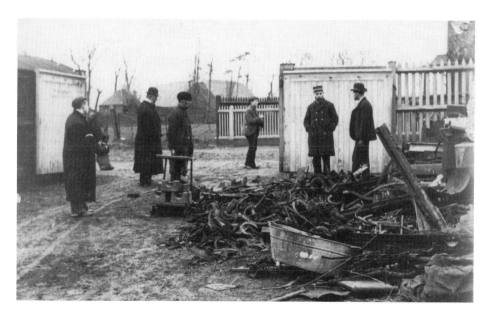

What looks like a scrapyard, perhaps near Wembley station. This photograph was probably taken before 1910, when the station was called Sudbury & Wembley. The man in uniform is Mr Fruin, Wembley's stationmaster for many years. He is speaking to Mr Dick Chambers, perhaps the cat owner depicted in the Alperton chapter earlier. The man in the overcoat and bowler hat is Mr Williams, who owned the only 'growler' in Wembley. A growler was a four-wheeled cab, as opposed to the better known two-wheeled 'hansom'. (8892)

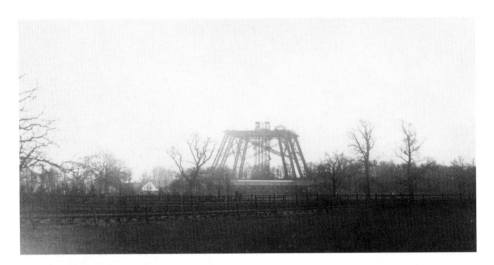

Wembley Tower, Wembley Park, early 1900s. The Tower was known disparagingly as 'Watkin's Folly' after Sir Edward Watkin (1819–1901), the former chairman of the Metropolitan Railway, whose idea it was to create an imitation of the Eiffel Tower in the London suburbs. It never rose beyond the first storey, and what remained of it was removed in 1907. Wembley Stadium was erected on the site, opening in 1923. This photograph was donated by the granddaughter of Henry Haynes, the Alperton builder. (8883)

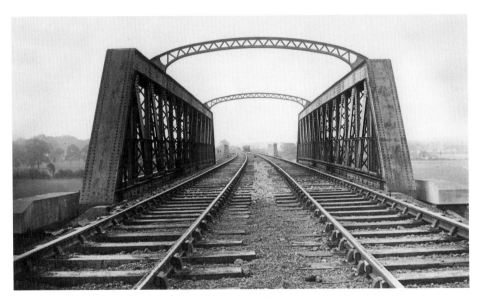

The Great Central bridge over the London & North West Railway line, 1905. The bridge was on a section of line that was laid down between Neasden and Northolt Junction (now South Ruislip) to connect with the newly built Great Western & Great Central Joint Line, which rejoined the Great Central at Grendon Underwood, Buckinghamshire. The joint line opened in 1906. It was designed to be more suitable for expresses than the previous route (via Aylesbury), but suburban services also used it. The bridge, just west of St John's Road, is still used by Chiltern Railways trains today. (9709)

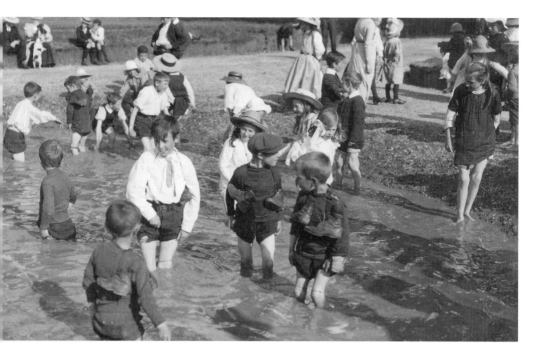

Children playing in the open-air paddling pool on the opening day of the King Edward VII Park, 4 July 1914. This scene was given the humorous title 'Water Rats' by the photographer, Kuno Reitz. Reitz returned to the park about fifteen years later to take an updated view of the improved pool, which was used as an illustration in the 1931 edition of the *Wembley Official Guide*. (9664)

The public bar of the original Greyhound, Wembley Hill, 1920s. Initially a house, the Greyhound was listed as a beer-shop in 1841. This room, which manages to look both cosy and seedy at the same time, would have sold beer at a lower price than the more salubrious main bar, which can be seen on p. 52 of Geoffrey Hewlett's *Images of London: Wembley* (2002). On 28 April 1923 this pub was crammed with West Ham and Bolton Wanderers fans attending the first ever Wembley FA Cup final, the famous 'White Horse Final'. They would have been drinking beer costing around 7*d* a pint. The building was demolished six years later. (9676)

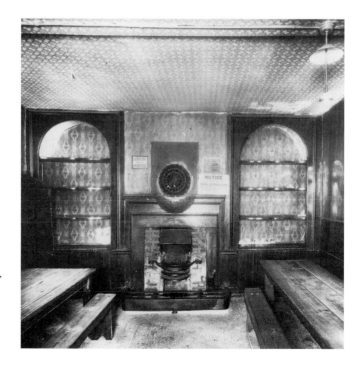

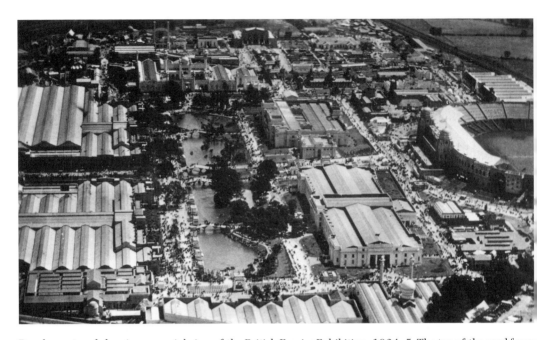

Beagles postcard showing an aerial view of the British Empire Exhibition, 1924–5. The top of the card faces east. In the centre the artificial lake divides the Palaces of Industry and Engineering (to the left) from the Australian and Canadian pavilions (to the right). The Indian Pavilion is beyond the lake, while New Zealand occupies the centre foreground, with Malaya to its south. The Empire Stadium can be seen on the right. Only a part of the Palace of Industry survives, as warehouses, but this is due to be demolished in 2011–12 to make way for the next phase of the 'Wembley City' redevelopment. (903)

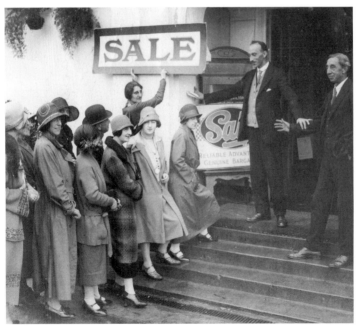

Women outside a sale, possibly of china or ceramics, at the British Empire Exhibition. They are wearing very typical mid-1920s clothing, with dropped waists and cloche hats. As well as the palaces and pavilions, there was also a strong commercial side to the exhibition, which must have complemented the demonstrations of products and craftsmanship. This photograph dates from 1925, probably during the closing days of the exhibition. For another view of the final days of the exhibition, see p. 190 of G. Hewlett's *A History of Wembley* (1979). The BEE was not as well attended in 1925 as it had been the previous year. (9743)

West Court, North Wembley, in the late 1950s or early 1960s. Situated off Shelley Gardens, north of East Lane, West Court is first mentioned in *Kelly's Directory* in 1933, when many of the houses were not yet listed. This seems to be the southernmost of the street's two typical suburban 'banjos', so-called because of their similarity in shape to the musical instrument. The photograph was taken to create a Francis Frith postcard, a last gasp of the early twentieth-century craze for publishing postcard views of residential streets. (8820)

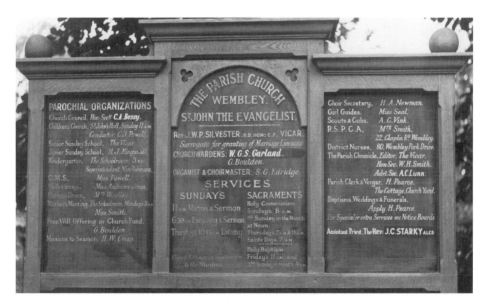

The noticeboard of the parish church of St John the Evangelist, Wembley, taken by Walter Roberts in about 1936. It is interesting to note that even the RSPCA came within the remit of the parish. The parish church of St John was built in 1845. Local benefactors Anne and Frances Copland provided the funds to build it on land from their own estates. The architect was Sir George Gilbert Scott, who designed it in the Gothic Revival style. Until its construction, Wembley was in the parish of Harrow, a long distance and a steep climb away. The vicar from 1896 to 1944 was J.W.P. Silvester, father of the famous band leader Victor Silvester. (9523)

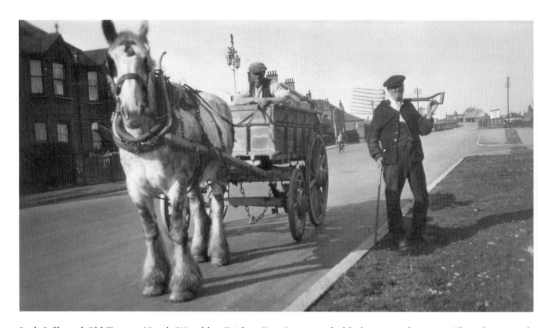

Jack Jeffs and Old Tom at North Wembley Bridge, East Lane, probably between the wars. This photograph was taken looking west towards the bridge over the London to Birmingham railway, with the entrance to what was or became GEC to the right. The two men may have been working for Wembley Council. (9649)

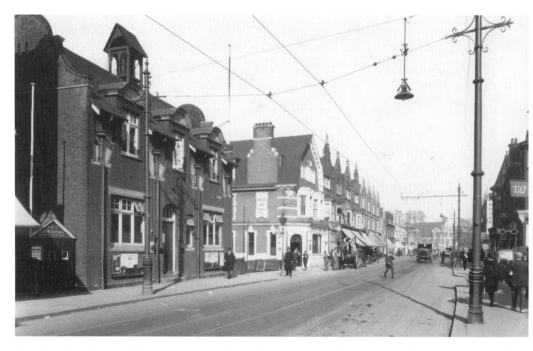

Wembley High Road in 1924, showing the Urban District Council office in the left foreground. The building was demolished in 1962 to make way for a large branch of British Home Stores (now Primark). This photograph was taken by Kuno Reitz. (9235)

Wembley's Charter Day.
The Charter Mayor of Wembley,
Cllr Edwin John Gover Butler
(Butler's Green, Sudbury, is
named after him), and Town
Clerk Kenneth Tansley, are seen
here receiving the Lord Mayor of
London and the Lord Lieutenant
of Middlesex on 2 October 1937
at the celebrations for Wembley's
Charter of Incorporation as a
new borough. Wembley Urban
District Council had merged
with the smaller Kingsbury
UDC in 1934, making it one
of the largest urban districts
in the country. It would now
be a borough until it merged
with Willesden to form Brent in
1964–5. (9747)

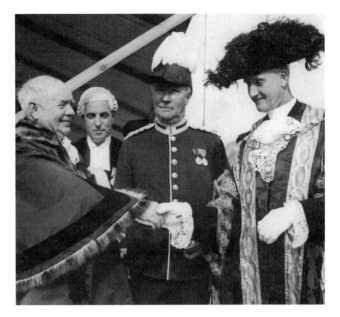

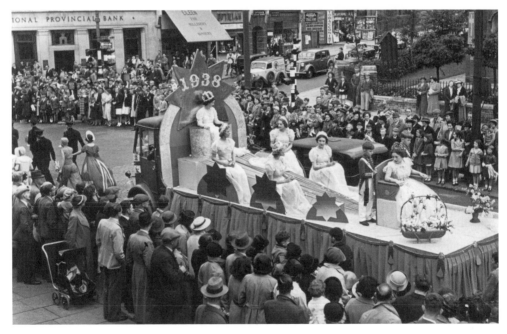

A float carrying Peggy Webb, 'Miss Wembley 1938', passing the junction of the High Road with Park Lane during the Wembley Carnival procession, 16 July 1938. According to the *Wembley News*, which published this photograph, 'crowds applauded all along the route.' When interviewed later, Miss Webb, who worked in a central London shoe shop, but was planning to become a dancing teacher, said that 'it made a change and was great fun.' The carnival raised money for Wembley Hospital in Chaplin Road, which largely depended on charity until the introduction of the NHS in 1948. The building to the right is the Methodist Church, which had opened in 1925 but would be demolished in 1961, to be replaced by Chesterfield House. (9439)

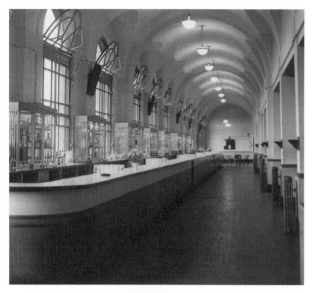

The Long Bar at Wembley Stadium, taken by the stadium's photographic department. From internal evidence, i.e. the style and décor, this was probably taken in the 1930s. The British Empire Exhibition plan included an Empire Stadium. The first turf was cut on 10 January 1922, on the site of the old Wembley Tower. Entrepreneur Jimmy White bought the exhibition buildings and stadium as a lot in 1925, and his employee Arthur Elvin demolished some and sold others. The stadium, however, was saved when Elvin formed the Wembley Stadium and Greyhound Racecourse Company. (9296)

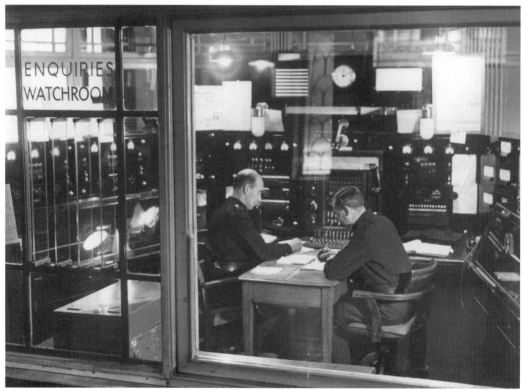

Firemen on duty in the watch room at Wembley fire station. Wembley Council set up a full-time professional fire brigade in 1935–6, after forty years of relying on part-time volunteers. The brigade's new fire station in Harrow Road had been built by 1939. The lighting, style and general appearance of the room suggest that this photograph was taken soon afterwards. It was clearly taken by a professional photographer and has something of the feel of a film still. (9293)

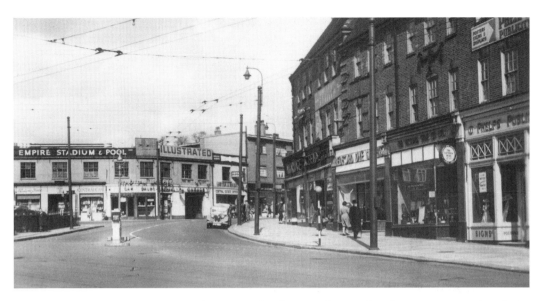

Wembley Triangle in the 1940s or early 1950s. The photograph was taken from Harrow Road, with the shops of Neeld Parade to the right and the junction with Wembley Hill Road just beyond them. The offices of the *Wembley News* were just round the corner, at no. 12 Neeld Parade, during this period. In the 1930s Phelps Publicity had shared no. 12 with the *News*, but had moved to no. 1, to the right of the photograph, by the time this picture was taken. Note the arrow to the 'Empire Stadium & Pool' and also the trolleybus wires. (9450)

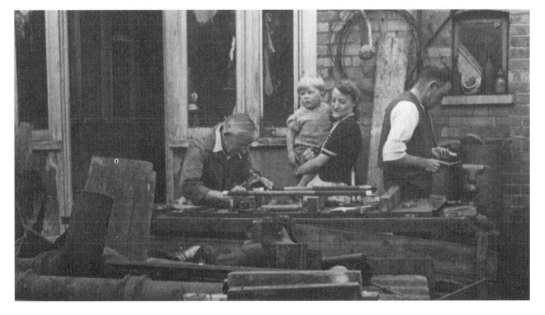

Howard's plumber's shop and yard, Wembley, 1942. The Howards had a family plumbing business, H. Howard & Sons, in Swinderby Road during the 1940s. The photograph was given to Brent Archives in 2006 by Mr F. Howard. Appearing in it are his uncle Ern, Betty Howard with her child Bobby Howard and Harrold Sydney Howard, the donor's father. (3889)

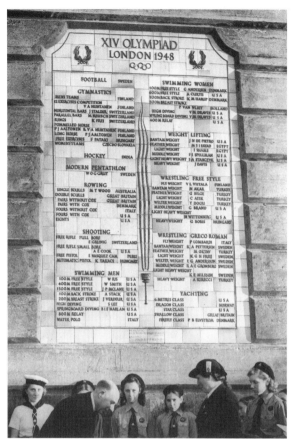

Sir Arthur Elvin, chairman of Wembley Stadium, under one of the two 1948 Olympiad roll of honour plaques at the main entrance to Wembley Stadium. This photograph probably dates from 1950, as Elvin is signing one of the scrolls containing messages of friendship which travelled round the country to mark the World Conference of Girl Guides, which was held at Oxford in that year. (9297)

Wembley Park Drive, probably in the early 1960s. The low-rise office block in the distance is Associated Rediffusion's Wembley Studios. Rediffusion provided ITV's London broadcasting from 1955 to 1968. Popular programmes recorded here included *No Hiding Place* (1959–67) and *The Frost Report* (1966–7). The building in the photograph has been demolished, but Studio 5, the largest television studio in Britain, still survives as studios A and B of Fountain Studios. The popular talent show *The X Factor* is filmed there. (8828)

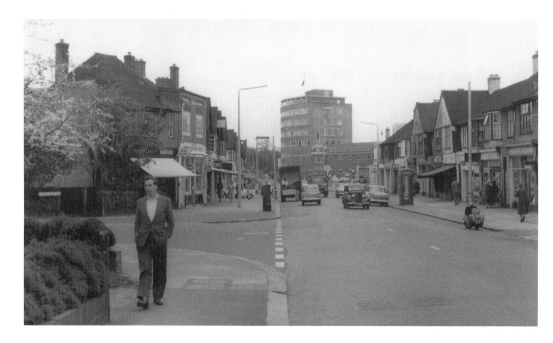

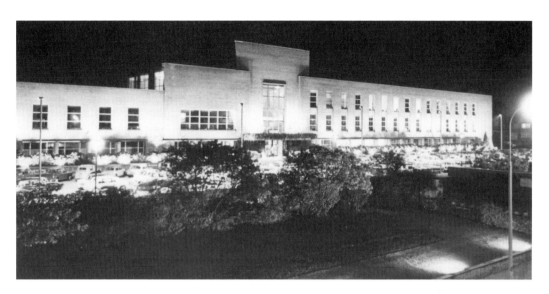

Brent Town Hall, formerly Wembley Town Hall, at night, *c.* 1966. Built on Forty Lane between 1937 and 1940, some described the project as 'Wembley's Folly'. The architect was thirty-three-year-old Clifford Strange, who followed his former employer T.S. Tait in imitating the Dutch architect Dudok, who had built Hilversum Town Hall. Unlike many Continental modernists, Dudok used brick rather than reinforced concrete. This made him very popular with British architects, who generally had conservative patrons. Nonetheless, most British town halls of the period were less innovative than Wembley's. (9745)

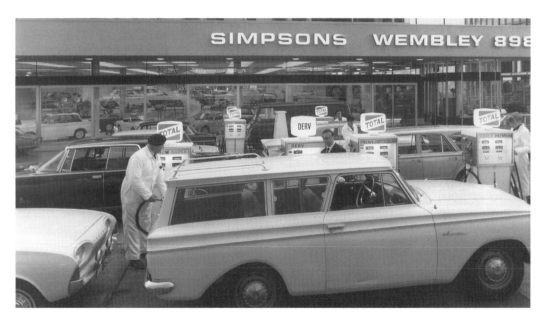

Simpsons service station, Elizabeth House, 341–5 High Road, 1965. When this station opened on 25 February 1965, it was claimed to be the largest single service station in Europe. It had cost £300,000, was capable of refuelling thirty vehicles simultaneously and could store 69,000 gallons of fuel. The attendant, in white overalls and beret, and looking as if he should be crewing a military bowser, is a far cry from modern self-service petrol pumps. (9121)

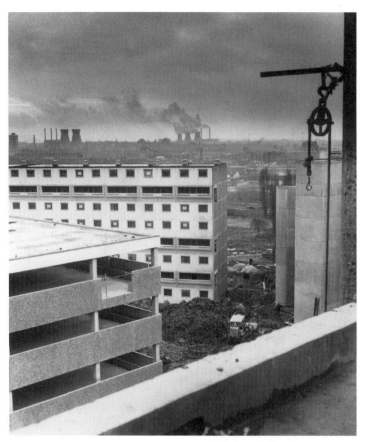

A *Wembley News* picture of the new Chalkhill housing estate under construction sometime between 1966 and 1970. The view shows the building of car park B and block E2. One of the early controversial decisions taken by the new Brent Council in 1965 was to build this estate to alleviate housing shortages and move residents from older areas of substandard housing such as South Kilburn. The two power stations in the distance are Taylor's Lane (left), which closed in 1972, but was rebuilt as a gas-oil facility and reopened in 1979, and Acton Lane (right), which closed in 1983. Chalkhill is technically in Kingsbury, but is best considered with Wembley, given the presence of the former Wembley (now Brent) Town Hall on Forty Lane, and the proximity of Wembley Park Underground station. (9550)

Political graffiti, Central Square, 22 June 1968. Parking had become a problem in Wembley as early as the 1950s, so between 1963 and 1965 a disused railway goods yard next to Wembley Central station was roofed over, creating an underground car park and an open shopping precinct called Central Square. Some of the shop units clearly still had not been let in 1968. This anti-Vietnam War graffiti was daubed slightly more than three months after the Grosvenor Square disturbances and only a month after *les événements de Mai* in Paris. (9781)

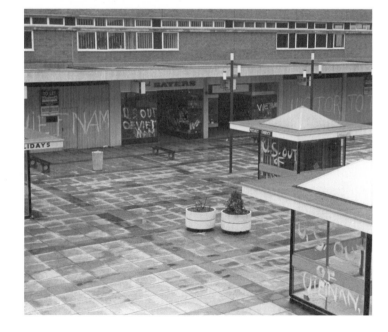

A *Wembley News* photograph of Killip's department store, 576–86 High Road, October 1970. Killip's began at 164 High Road and later moved. The original founder of the store, John T. Killip, was a past president of Wembley Rotary Club. Killip's was one of forty national winners of a Distributive Industry Training Award in 1977, for the excellence of its staff training. By 1971, Wembley High Road itself was ranked as the eleventh best place to shop in London, with shoppers coming from several miles around. Killip's, however, closed in June 1979. (9203)

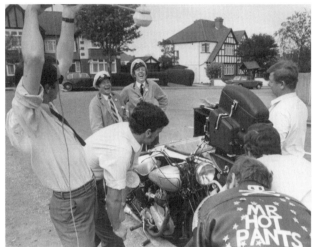

Filming the popular ITV comedy series *On the Buses*, starring actors Reg Varney and Bob Grant, near East Lane School in the week beginning 16 May 1969. *On the Buses* ran from 1969 to 1973, having been first rejected by the BBC. The programme used to be recorded at London Weekend Television's studios in Empire Way, Wembley (the former Rediffusion studios mentioned above), before shifting production to new studios on the South Bank in 1972. (9292)

The garden of the Torch pub, Bridge Road, Wembley Park, 1964. The Torch, named to commemorate the place where the final torch carrying the 1948 Olympic flame was lit, had won second prize in the small gardens category in the Courage (Eastern) Limited Gardens & Floral Decoration Competition. In 1964 the landlords were Mr and Mrs D.F.C. Duncan. This pub opened in 1956 and is still a popular meeting place for those attending events and concerts at Wembley Stadium. (9311)

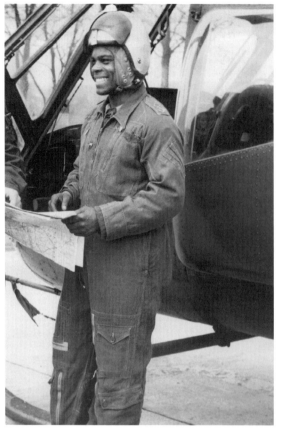

Thirty-year-old Bombardier Steve Prescod, a helicopter observer with 659 Squadron of the Army Air Corps, April 1970. The son of Mr and Mrs G. Prescod of no. 13 Berkhamsted Avenue, Wembley, he was stationed at Osnabruck in Germany. The accompanying press release says 'the qualification "observer" is a new one in the Army' (unless, presumably, one includes the pre-1918 RFC) and that Steve Prescod was one of the first men to gain it. He was also a motor transport NCO and the squadron's physical training instructor, as well as 'an ex-welterweight champion of both the British Army of the Rhine and Kent County'. (Imperial War Museum)

A parents' meeting on the subject of overcrowding at Park Lane School, 11 January 1971. This is another *Wembley News* photograph. In 1971, the Park Lane School headteacher, Mrs Clarkson, was suspended in a dispute over overcrowding at the school. She had raised concerns about safety when sending young children across the road to overspill classes in the Methodist Church Hall. Fourteen teachers walked out in support of her stand and the school had to close, allowing the pupils an unscheduled extra week's Christmas holiday. (9285)

The President of the Wembley & District Scottish Association, Mrs Grace Porter, and Mr Porter, receive guests Mr and Mrs Lewis Wright at the annual Burns Night Supper, in the 1970s. (9484)

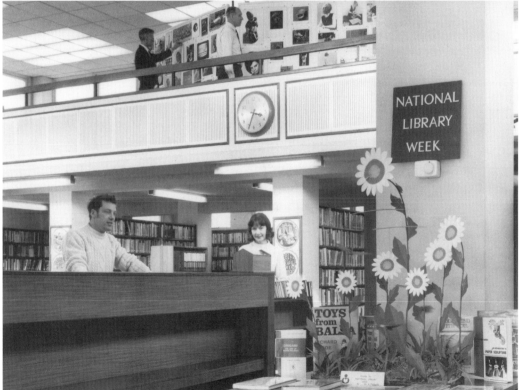

Mounting Wembley Camera Club's display at Ealing Road Library on 9 March 1969, as part of National Library Week. In the top left of the photograph is R.J. Pales, a keen photographer. Margaret Clark, assistant librarian, and D. Williams, librarian, can be seen on the bottom left of the photograph. (9511)

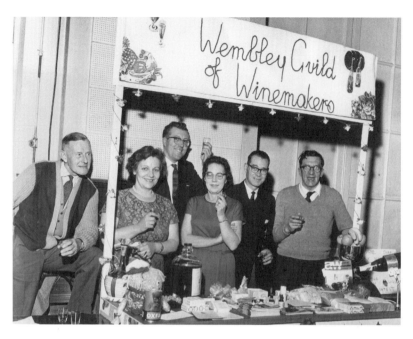

The Wembley Guild of Winemakers, in what looks like the 1960s. Now called the Wembley Guild of Wine & Beermakers, the organisation is a member of the National Association of Wine and Beermakers (Amateur). (9784)

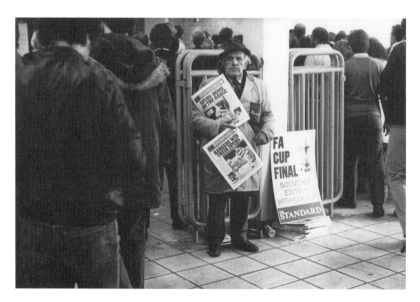

A photograph by Michael Foale showing a newspaper vendor at the 1982 FA Cup final, 22 March 1982. Tottenham Hotspur drew 1–1 with Queen's Park Rangers after extra time. Foale was born in Kingsbury and had been a steward at Wembley Stadium while in the Boy Scouts. The vendor is selling copies of the *Evening Standard* with alternative front pages and headlines. Spurs went on to win the replay on 27 March. (8919)

SIX

KINGSBURY

Kingsbury first entered recorded history 1,000 years ago. Its name meant 'King's Manor'. In the fourteenth century, the population of twenty-three families lived in a few scattered farms, with a village centre focussed on Kingsbury Green. The Black Death wiped out most of the inhabitants of the original settlement near the church. The loss of population in the southern part of the parish was made up for by a slight increase in numbers at Kingsbury Green and The Hyde.

Kingsbury Green and The Hyde continued their growth during the Victorian period. The population had trebled by 1851 and a new church, Holy Innocents, had to be provided in 1884 where newer residents were by then living.

The writer Oliver Goldsmith lived at Hyde Farm from 1771 to 1774, while John Logie Baird made the first television transmission from the coach house of Kingsbury Manor in the late 1920s. In the twentieth century Kingsbury moved from dependence on hay and animal farming to being a centre of aircraft and munitions manufacturing during the First World War. Land was sold off for factory space. Of the many local airfields, only Stag Lane survived the war, closing in 1934.

The need for new housing for aircraft workers was met with the construction of Roe Green Garden Village, a model development by the architect Frank Baines. Despite this, Kingsbury was still well regarded in the 1920s because of its unspoilt rural character.

Initially part of Wembley Urban District, Kingsbury became a seperate UDC in 1900. Kingsbury Urban District Council was responsible for one of the earliest council estates in the present Borough of Brent, in 1924 at High Meadow Crescent. Better transport links such as the Metropolitan line extension to Stanmore in 1932 helped to draw potential homeowners and developers to Kingsbury. The area suburbanised rapidly. In 1934 Kingsbury Urban District was merged with Wembley UDC, becoming part of the Borough of Wembley in 1937.

Old St Andrew's Church in the 1890s. There is some architectural evidence that Old St Andrew's dates from before the Norman Conquest of 1066. Recent archaeological work suggests that its walls were constructed by the year 1100. A number of changes to the building have been made over the centuries. The vestry, with its large chimney, was built as part of renovation work in 1889. This photograph was donated by London Borough of Barnet Archives. (9785)

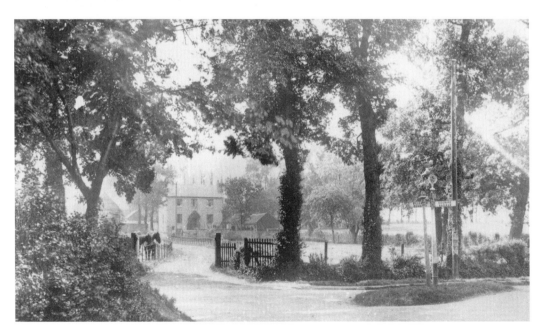

Big Bush Farm Kingsbury in the 1920s or '30s. This image is from a postcard showing the farmhouse and drive as seen from the junction of Salmon Street and Slough Lane. There was a farm on this site, originally called 'Richards', since the fourteenth century, and its former fields are now part of Fryent Country Park. The farmhouse disappeared in about 1939, but its garden still exists as a small orchard tended by Barn Hill Conservation Group, and horses are still stabled in the old barn. The road sign suggests that this is an inter-war scene. (479)

Kingsbury cricket team, *c.* 1901. Some of these men may have seen Charles de Trafford's Australian tourists beat neighbouring Wembley Park Cricket Club by 135 runs only a few years earlier, on 8 and 9 June 1896. Australia took back the Ashes in the same summer, and held them until early 1904. (8792)

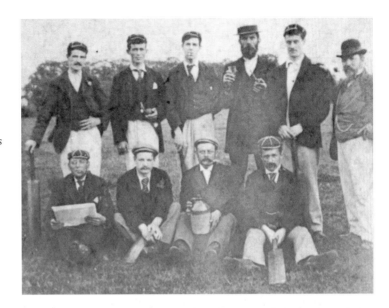

The Plough public house, Kingsbury Green. This photograph shows the pub with bay windows on either side of the entrance, indicating that it postdates the enlargement of the building in 1912. Previously, as a photograph from 1910 shows, there was just one bay window, to the right of the entrance as one approached it. This pub, first recorded in 1748, was one of six at Kingsbury in 1751. During the early nineteenth century the building was often the venue for Kingsbury Vestry meetings. In late Victorian times it was also a popular destination for ramblers and cyclists. It was demolished in 1932 to make way for the present structure. This changed its name to the Great Eastern in about 2000 and, after another refurbishment, it reopened as the Jewel, an Indian restaurant and bar, in 2009. This too had closed by 2011. (9810)

A group photograph of the Fabric Machinists' department at the Aircraft Manufacturing Company, taken from the December 1917 edition of the *Aircraft Rag* magazine. The company was set up at The Hyde in 1912. Geoffrey de Havilland joined two years later, designing the DH2 fighter (1915) and the DH4 and DH9 light bombers during the First World War. The company went bankrupt in 1920, owing to over-reliance on military orders. De Havilland formed his own company from its assets in the same year. A large number of women worked at the factory during the war, but this photograph is rare in that it shows an all-female department, without male supervisors. (6022)

A 1930 photograph showing a suburban home designed by local architect Ernest George Trobridge (1884–1942). The house formed one end of Unwerelm Studios, Hay Lane, a long two to three storey block containing several homes, built entirely of timber and with a thatched roof. This was part of Trobridge's Elmwood Estate, constructed between 1922 and 1924. The building was pulled down to make way for a row of shops in 1931. Examples of Trobridge's picturesque thatched cottage style can be seen in Slough Lane, Stag Lane, Hayland Close and Buck Lane. He later designed blocks of flats disguised as castles, which expressed his eccentric vision and medieval tastes. His designs provided quality housing that was also affordable. (9845)

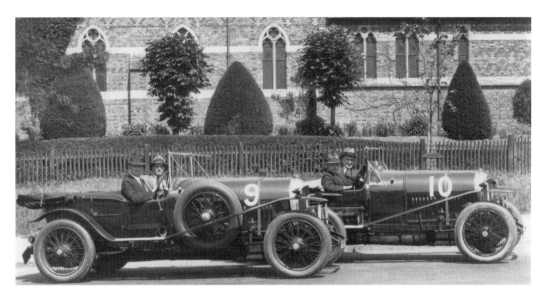

Bentley racing cars outside Holy Innocents' Church, June 1925. Bentley began production in a mews off Baker Street. In 1920 they bought land at Oxgate Lane, Cricklewood, and set up a factory there. From 1923, the bodywork for the cars was made by Vanden Plas at their nearby Kingsbury Works, part of which was used by Bentley as a special workshop for racing cars. In this photograph car No. 9 has Capt J.F. Duff, driving, with co-driver F.C. Clement. The driver of No. 10 is H. Kensington Moir, with co-driver Dr J.D. Benjafield. The cars raced at the Grand Prix d'Endurance at Le Mans on 20–1 June 1925. Both vehicles had to retire, No. 9 because it caught fire after sixty-four laps, and No. 10 because, owing to a miscalculation, it ran out of petrol after nineteen laps. (8858)

Lewgars House, Slough Lane. A house had probably existed here since the thirteenth century. The building in this photograph dated from the eighteenth or early nineteenth century, but in 1872 its owner, the antiquarian E.N. Haxell, extended it, adding the castellated, ecclesiastical gothic west wing which can be seen here. Haxell used part of St Andrew's Church spire (replaced in 1870) to build the bell tower. He took other parts of the

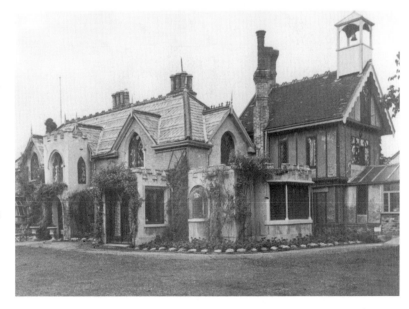

church as well – he turned the font, which had been thrown in a pond during a previous restoration (1840) into a garden ornament. It was returned to the church in 1904. The house was demolished in 1952, after having been empty for over a decade. Tunworth Close was built on the site. (8991)

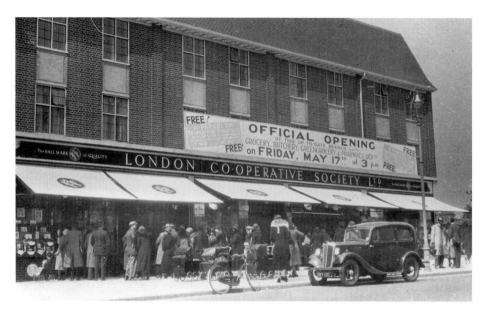

The opening of the new Co-op, Kingsbury Road, Friday, 17 May 1935. As the sign said, the shop comprised grocery, butchery, greengrocery and pharmacy departments. Anyone joining the society at the Kingsbury shop between 17 and 25 May received 'a parcel of Co-operative productions' free. (2694)

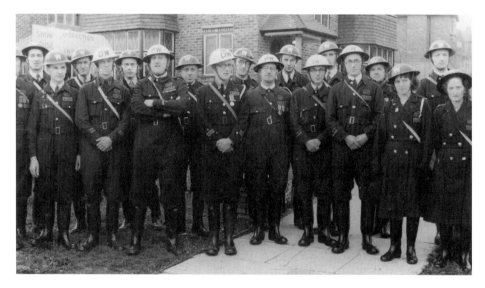

A group of ARP wardens at the ARP headquarters, by the corner of Greenhill and Salmon streets, 24 May 1941. They are standing in front of a show home, demonstrating how Kingsbury's suburban development was interrupted by the Second World War. The government decided to create a national Air Raid Wardens' Service in 1937 and over the following year recruited about 200,000 volunteers. Their main purpose was to patrol the streets, looking for any lights showing from windows, in breach of the general 'blackout' rule. They also reported the extent of bomb damage and handed out gas masks. (874)

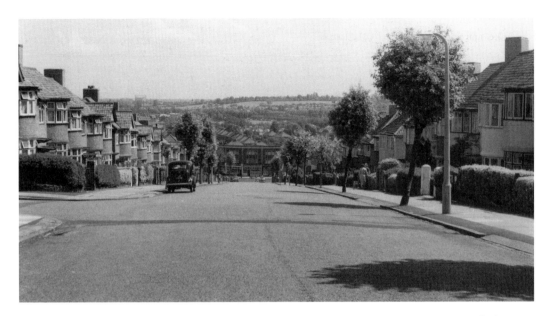

Wakemans Hill Avenue, looking roughly east towards the Edgware Road, late 1950s or early '60s. At this date suburban streets like this still looked much as they did in the 1930s, when the houses had been built. Today many householders have been obliged to convert their front gardens into extra parking, greatly uglifying the street scene. (8850)

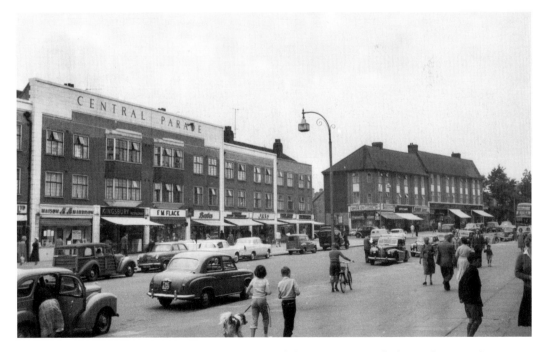

Shopping at Central Parade, 532–46 Kingsbury Road, late 1950s or early '60s. This run of inter-war shops is now occupied by Rose Indian/Chinese Restaurant at 532–34, William Hill at 536, Alpine Wine at 538, B4 Dry Cleaning at 540, Anand Indian Sweets at 542 and HSBC at 544–6. (8846)

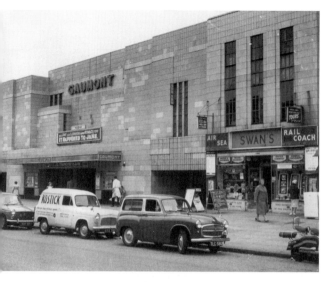

The Gaumont Cinema, Station Parade. This cinema opened in 1934 as the Odeon. It was known as the Gaumont from 1950 to 1964. It is showing the film *It Happened To Jane*, a Doris Day comedy of 1959. This image was destined for use as a Francis Frith postcard, and bears an instruction to remove the film name so the card would remain undated. The Gaumont British Picture Corporation dominated the film industry, with a large chain of cinemas, and film studios at Lime Grove. This cinema closed down in 1972 and was demolished to make way for a Sainsbury's supermarket, which opened in 1979. After Sainsbury's withdrew from Kingsbury Road in 1997, the site was taken over by the German supermarket, Aldi. (8844)

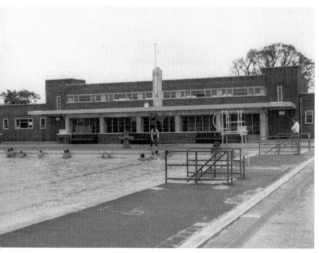

Kingsbury Swimming Pool, late 1950s or early '60s, with the elm trees of Bacon Lane behind. The idea for a public pool was being considered by Kingsbury Urban District Council before it merged with Wembley in 1934, but it was Wembley's Engineer and Surveyor, Cecil S. Trapp, who recommended a site in the new Roe Green Park and drew up the plans. The Olympic-sized pool was officially opened in May 1939. Many local schools taught their pupils to swim here. Due to a steady decline in attendances and revenue, it closed in 1988. Between then and 2005 various redevelopment plans fell through, and the council finally dropped the idea for a new pool on the site. (8836)

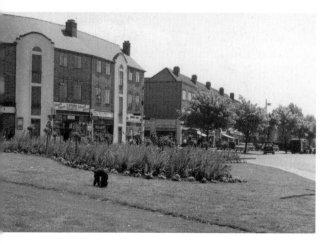

Suncrete Parade, Kingsbury Road, again in the late 1950s or early '60s. This shopping parade was built in 1934 on the site of Suncrete, a large, detached concrete house with a green pantiled roof, built in 1927 by the *Sunday Chronicle* newspaper to a design by architect Reginald Blomfield. The house was given away as a prize, probably in connection with the Ideal Home Exhibition. (8849)

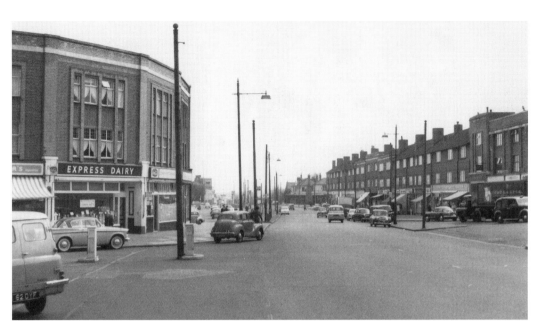

The Hyde, Edgware Road, looking south, early 1960s. The border between Brent (then Wembley) and Barnet (then Hendon) runs down the middle of the road, with Brent on the right. Sheaveshill Avenue is the street coming in from the left, while Wakemans Hill Avenue is out of shot to the right. The Express Dairy shop reminds us that, from 1931, there was a large Express Dairy bottling plant at Claremont Road, not far away on the same side of the Edgware Road, at Cricklewood. The name The Hyde comes from a medieval land measurement. It was a small hamlet by the mid-sixteenth century. (8851)

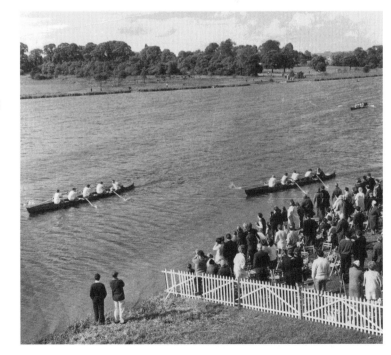

A *Wembley News* photograph of Brent's successful coxed four at Brent Regatta, 25 May 1969. Work on the construction of the Brent Reservoir began in 1834–5 to meet the need for an improved water supply for the Grand Junction Canal, and the canal feeder was ceremonially opened in 1838. Since this time, the Welsh Harp, as it was also known, provided ample opportunities for recreational activities. One of the most notable of these was the Willesden (later Brent) Regatta. This was a regular event in the 1940s, but came to an end after the 1960s. (9787)

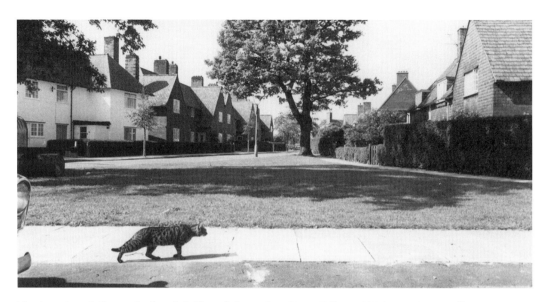

The junction of Shorts Croft and Goldsmith Lane, Roe Green Village, 1971. Roe Green Village comprises 270 flats and houses, largely built by the Government between 1918 and 1920 as a garden village for the employees of the Aircraft Manufacturing Company. It was partly constructed by prisoners of war. Writing around the time this photograph was taken, the authors of the *Victoria County History* said 'although it had lost some of its houses and trees, Roe Green Village, which had been made a conservation area in 1968, retained something of the atmosphere of a village green.' The cat, meanwhile, is clearly stalking something. . . . (9786)

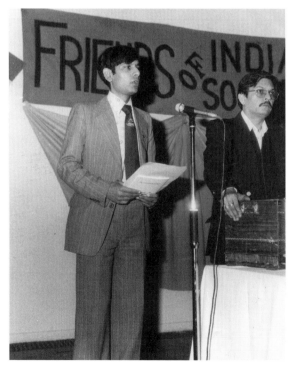

Mr C.V. Chavda of Church Lane, Kingsbury, making his thanksgiving speech at the Friends of India Society International (UK) celebration of India's Republic Day, Sunday, 29 January 1978. FISI was founded in the mid-1970s to co-ordinate opposition to the Indian State of Emergency. The UK chapter is one of eighty-six worldwide. According to the University of Oxford's Centre on Migration, Policy and Society, 'one of the aims of the organisation is to preserve and promote democratic processes, economic interests, human rights and civil liberties of Indians living in and outside India and to foster close cultural and personal links between [Indians] living abroad with their adopted homeland and India.' Chuni Chavda would later be Deputy Mayor of Brent. (9783)

SEVEN

CRICKLEWOOD

Cricklewood lies on Brent's eastern border and means 'the wood with an uneven outline'. Several farms existed in the area before the eighteenth century. Cricklewood was divided between the parishes of Willesden, Hendon and Hampstead, with most of the dwellings on the Hendon side of the Edgware Road. In 1845, Cricklewood was described as a village one mile long, mainly inhabited by tradesmen.

Overall, Cricklewood did not profit from its situation on a main road. Indeed, it was notorious for highway robbery in the late eighteenth century. In 1870 the Midland Railway built a station, originally called Child's Hill, then a more important locality, but renamed Cricklewood in 1903. Cricklewood remained largely rural until at least the mid-1870s, when there were as many as thirty-six houses and an inn called the Windmill on the Willesden side. Chichele Road was laid out on land owned by All Souls College, Oxford, in 1889, and by the turn of the century Cricklewood was greatly enlarged. Between 1910 and 1914 the district got a shopping parade on both sides of Edgware Road, followed by a cinema and other amenities.

As Cricklewood grew, it needed improved local transport. By 1900 there were regular buses from the Crown public house to Hendon and Charing Cross, with trams running from Edgware to Cricklewood from 1904.

After 1900 Cricklewood became known for its industries, such as the Phoenix Telephone Company and Smith's potato crisps, first produced in a garage behind the Crown. Smith's Industries, an unrelated clockmaker's, became the town's main employer, with a labour force of 8,000 by 1939. In 1912, Handley Page also established their aircraft production factory on Cricklewood Lane. There was even a film studio in Temple Road.

In the 1920s, there was notable Jewish immigration into Cricklewood. There was significant Irish immigration after the Second World War. Later twentieth-century immigration came from the West Indies and the Indian subcontinent, and many smaller communities also settled in the area, yet, by the 1960s, Cricklewood's industry was in decline.

During the 1990s, after our period, various positive changes revived the area.

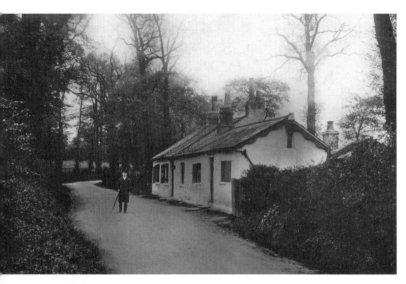

A Richardson & Co. postcard of Old Cottages, Oxgate Lane, Cricklewood, produced between about 1906 (when the company first appears), and 1917 (when the card was posted). In the 1920s and '30s houses and flats were built at Oxgate, with new bus services connecting Cricklewood with Neasden, thus utterly transforming a hitherto rural area. (8016)

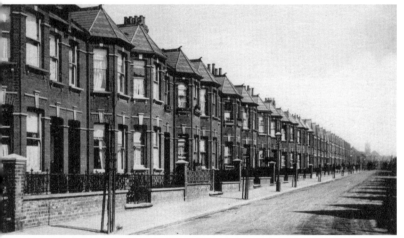

Olive Road, Cricklewood, before 12 May 1909. This was part of George Furness's Cricklewood Park Estate, where the streets were named after trees. Olive Road is the location of Cricklewood Library, which opened in 1929 on land owned by All Souls College, Oxford. The building once housed Brent Archives. (8112)

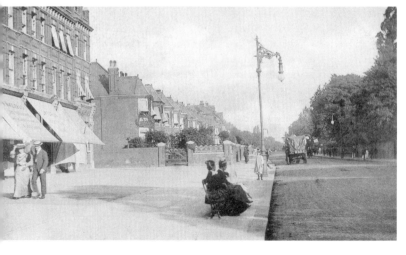

A Reeves postcard of Cricklewood High Road, looking south just before the junction with Manstone Road. Everything to the left of the picture is in the modern Borough of Camden. Other than the fact that the shops now have single-storey extensions, reducing the width of the pavement, this view does not look very different today. The card was written on 5 October 1904. (8667)

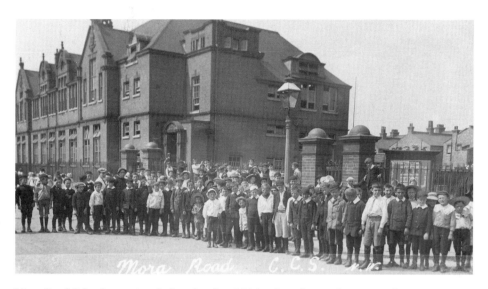

Mora Road School sometime before October 1911, when this card was posted. Mora Primary opened on 22 July 1907 as a council school for 400 boys, 400 girls and 400 infants. The opening of the school was performed by Judge Rentoul, KC, LLD. The school was built in what was then fairly open countryside and was named after the road of its location, itself the name of a South American oak tree, in keeping with the other road names in the area. The *Mora* was also the name of the ship which brought William the Conqueror over to England to defeat King Harold at the Battle of Hastings, in 1066. (8144)

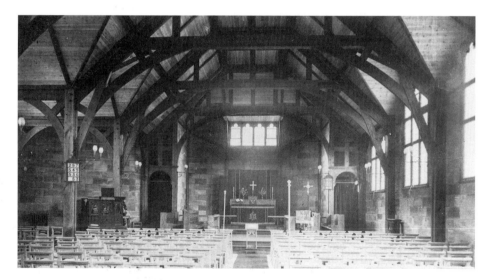

A postcard showing the interior of St Michael's Church, St Michael's Road, posted on 18 September 1914. This view, showing a building with a barn-like roof, looks like the interior of the 1907 mission church. It shows how well-appointed such temporary churches could be. A permanent church building, seating 754, was completed in 1909, and this building became the church hall. The parish was created in 1910, but later became dependent on St Gabriel's. Today the 1909 building is St Michael's Apostolic Church, while this structure is Living Spring Montessori nursery school. (1428)

Cuthbert McEvoy, minister of Cricklewood Congregational Church, Chichele Road. The photograph dates from between 1898 and 1903. The church, which opened in 1902, was an offshoot of a church in Lyndhurst Road, Hampstead. McEvoy was a part-time master at Watford Grammar School, and resigned from his pastorate in 1920 to become a permanent member of staff there. Like many Congregational churches, the church closed in a merger with the Presbyterians in 1972, but the building is still a place of worship, serving as Brent Mosque and Islamic Centre. (6823)

A fine fleet of milk prams and a tricycle outside Aylesbury Manor Farm Dairy, 41 Cricklewood Broadway. Harry Clarke, farmer and dairyman, owned this shop from at least 1901 until 1910. It is just possible that Clarke produced this card to mark a change in street numbering, as it was posted in December 1906 and 41 Cricklewood Broadway was known as 2 Carlton Parade, Edgware Road, until 1905. *Kelly's Directory* for 1911 lists the premises as Fontyn & Co., grocers. (8230)

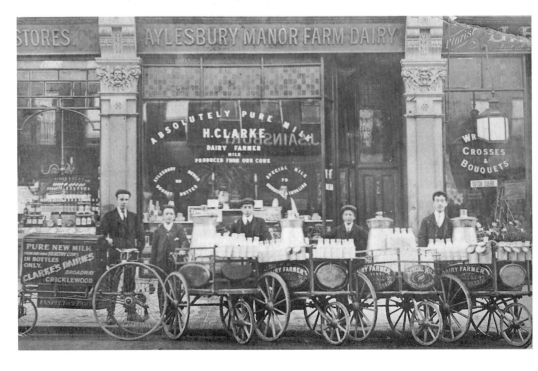

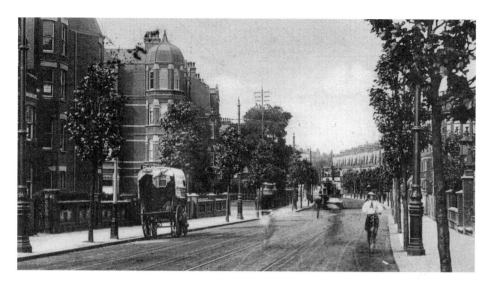

The junction of Anson Road and Chichele Road, looking towards Cricklewood. The block of flats with the impressive turret is Chichele Mansions, then only a few years old. There is a 'To Let' sign in a third-floor window of the left-hand building, and more flats are advertised to the right. This card was posted on 10 January 1908. (8185)

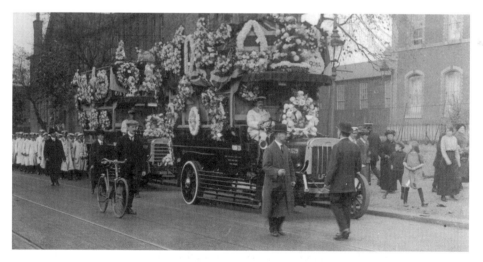

The funeral of driver Tarrant and conductor Rogers, 20 October 1915. Charles James Tarrant, aged thirty, of 43 Larch Road, Cricklewood, and Charles Rogers, aged forty-five, of 81 Temple Road, were the crew of a no. 13 bus operating from Hendon Garage on the night of the 'Theatreland' Zeppelin raid (13/14 October 1915). This raid, by five German naval airships, killed more people than any other Zeppelin raid of the war. Rogers and Tarrant died at Aldwych, along with a thirty-four-year-old special constable who was helping evacuate their bus. The busmen's funeral service was held in St Michael's Church, Cricklewood. After the service the cortège went down Cricklewood Broadway (shown here), Chichele Road and Willesden High Road to Willesden New Cemetery. The procession was nearly a mile long. 'All the way along blinds were drawn and every mark of sympathy and respect was shown.' (3269)

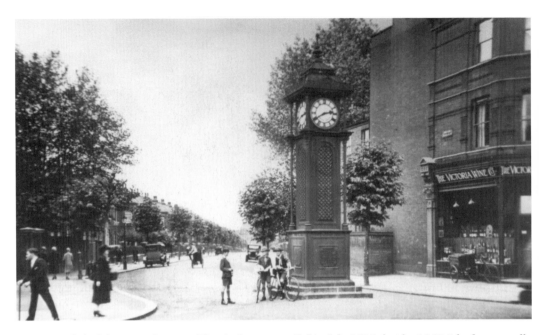

Anson Road clock between the wars. The clock was unveiled in July 1912, but by 1943 it had supposedly become so rusty and dangerous that it was demolished and the metal taken away to help the war effort. Victoria Wine traded at 83 Cricklewood Broadway for the entire inter-war period. The man with the stick and unusual gait to the left may well be one of the 1.6 million British servicemen wounded during the First World War. (6553)

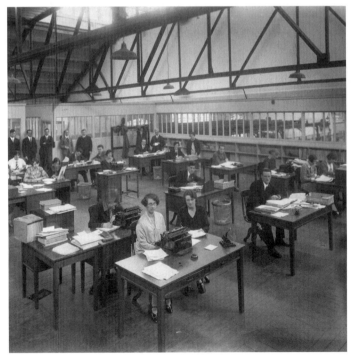

The Rolls Razor factory, showing clerical staff at work in a 1930s office. Rolls Razor had moved from Battersea to 255–89 Cricklewood Broadway in 1926. They manufactured safety razors with non-disposable blades. When the blade became dull, the owner sharpened it using a honing stone and a strop inside the attractive metal box. By the late 1940s the firm was moving into the electric shaver market. In 1952 they opened a new factory in Hemel Hempstead, but were forced to close it and return to Cricklewood a few years later. In 1959 the company stopped manufacturing shavers and turned to making washing machines instead. This enterprise failed and it went bankrupt in July 1964. (9790)

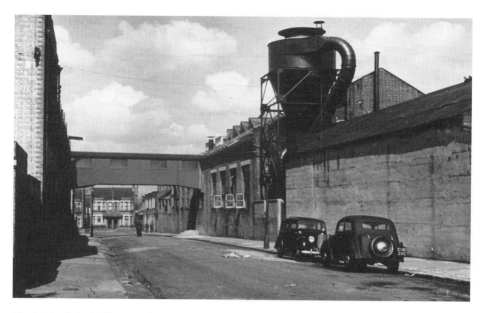

The back of the Rolls Razor factory, Hassop Road, Cricklewood, April 1948. (176)

The Kilkenny Association at the Galtymore dance hall, Cricklewood Broadway, 1950s. Irish people had been coming to Cricklewood as seasonal agricultural labourers (*spalpeen*) since the early nineteenth century or earlier, but significant immigration only came after the Second World War. Many Irish women became nurses. Irish men tended to work in construction, rebuilding blitzed properties and redeveloping slums. On Friday and Saturday nights these new residents, most of them young and single, would visit Irish venues like the Galtymore. This photograph was taken by Paddy Fahey, who lived in Brent and documented the Irish community all over London. (6441)

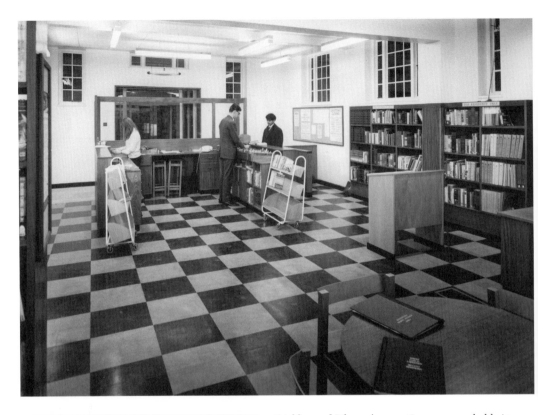

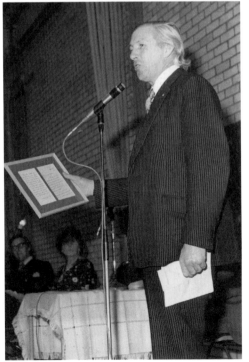

Cricklewood Library's reception area, probably in the 1960s. The photograph shows the counter as being nearer to the front entrance than it was in the early 2000s. Modern designs in Brent Libraries have dispensed with a main enquiry desk in this traditional style. (9789)

The opening of William Gladstone High School, 13 November 1975. The speaker is Sir William Gladstone, great-grandson of the famous Prime Minister. He is presenting the school with a framed letter written by Gladstone to Lady Aberdeen on 5 April 1883. The letter, which is now in Brent Archives, mentions the higher education of women and the charms of Dollis Hill, where Lord and Lady Aberdeen lived and where Gladstone was a frequent guest. William Gladstone School closed in the early 1990s. (9496)

EIGHT

HARLESDEN

Harlesden was originally called 'Herewulf's Tun' or Herewulf's farmstead. It began as a Saxon settlement in a woodland clearing. There was a thriving brick and tile works from the fifteenth century, and by the sixteenth century it had grown to a village of seven houses surrounding a green that bordered the Harrow Road. One of these properties was the main farmhouse of the estate owned by All Souls College. Harlesden had soon developed its own identity and in the mid-eighteenth century could boast two inns, the Crown and the Green Man. At the time of enclosure in 1823, there were thirty desirable middle class properties.

Significant development was only really stimulated by the arrival of the railway, when a station opened temporarily at Acton Lane in 1841, to be replaced by one at Willesden Junction in 1866. The new station spurred on the construction of Chapel Terrace opposite the Crown. This work led to the construction of numerous villas, many of them by the United Land Company. There was no adequate sewerage until 1871 and inevitable problems with sanitation ensued. Harlesden's High Street was rebuilt in the Edwardian period and several cinemas and a music hall, the Willesden Hippodrome, also opened at this time.

In 1907 local transport was boosted by electric trams and, in 1912, a new station for Harlesden was built on the electrified London & North Western Railway line. Public transport encouraged many small firms to set up factories in the area. In 1936–7 Willesden Council built their largest housing estate, Curzon Crescent, between Harlesden and Church End.

Although the population declined between 1951 and 1971, new immigration occurred in the 1960s from the West Indies and the Indian subcontinent, leading to concerns about social cohesion in the early 1980s. In the 1990s, there has been successful regeneration of the town centre and shops, and Harlesden has become a centre for the Black Music Industry. In 2001, it was featured, still controversially, in a BBC documentary series, *The Heart of Harlesden*.

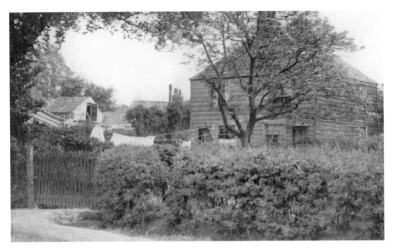

Pleasant Cottage, off Harlesden Lane. Here is a scene of a weatherboarded cottage in a rural setting, with washing hanging in the front garden, in the early twentieth century. This was published in the Allen's Series and was intended to show the kind of rural farm dwellings that were disappearing under the relentless drive of suburbanisation. (1120)

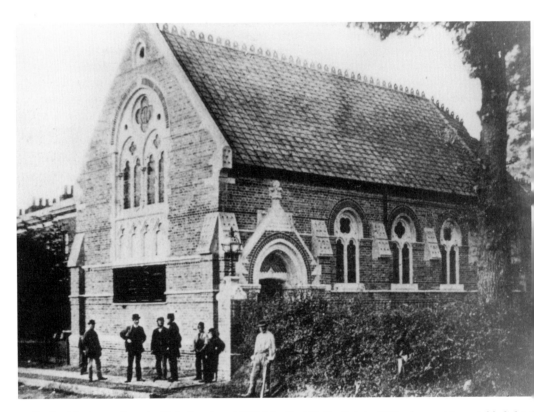

Willesden Wesleyan Church, High Street, *c.* 1870. The first Methodists in Willesden met in a stable loft in Harlesden between the Royal Oak and the Green Man, then, from 1847 to 1856, in a chapel north of the High Street. The church illustrated was built in 1869, opposite the Crown. It looks as if it was relatively new when this photograph was taken. A second, larger church opened to its north in October 1882, the smaller church becoming its Sunday School. The name was changed from Willesden to Harlesden Wesleyan Church in 1907. The new church was gutted in the Blitz and replaced in 1955–6. Somewhat ironically, given Methodism's historical connection with teetotalism, the 1869 church is now a pub. (2018)

A photograph of Glynfield House, Craven Park Road, showing a tall Victorian house with three Victorian young ladies seated outside it. Craven Park Road first appears in local directories in the early 1890s. (539)

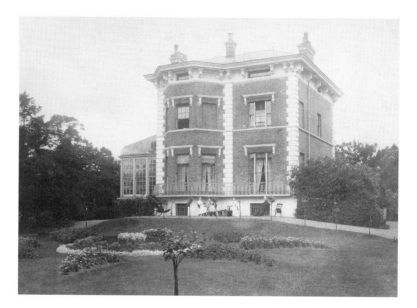

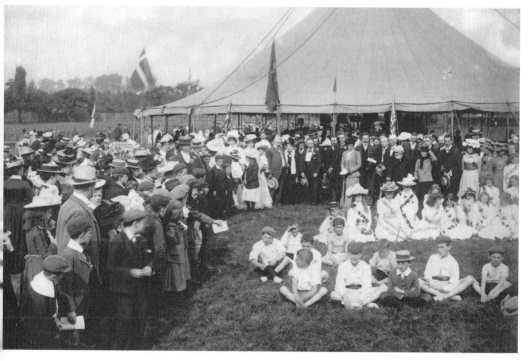

A Young Folks' Fête for Willesden Cottage Hospital, Shoolbred's Grounds, near Roundwood House, September 1900. By 1900 Willesden Hospital was 'in urgent need of funds . . . despite Mr. Passmore Edwards' benevolent provision.' Local builder George Furness, who lived at Roundwood House, organised this event to raise funds and to increase awareness of the hospital and civic duty among the young. The fête developed into the annual Willesden Hospital Carnival. It should not be confused with the May 1900 Willesden Carnival, which raised money for the *Daily Telegraph*'s Boer War Soldiers' Widows' and Orphans' Fund. (9846)

A Valentine & Sons postcard of Station Road and All Souls' Church, *c.* 1907. The view is of a curving Station Road, with All Souls' Church to the right, and an electric tram approaching round the bend, behind the man walking in a somewhat leisurely fashion in the middle of the road. Harlesden became part of the Parish of All Souls in 1875. The population of the parish increased from 2,390 in 1881 to 9,929 in 1891. At the turn of the twentieth century, the population of Harlesden was still mainly middle class and the former village by then offered nine churches and chapels to its community. (1047)

Harlesden Jubilee clock, post-1907. The Jubilee Clock was not actually erected until 28 January 1888, at a ceremony performed by a local worthy's daughter, Miss Audrey Goldney-Cary, although it had been planned to commemorate Queen Victoria's Golden Jubilee in 1887. A committee was set up to raise subscriptions in 1886, but it took a long time to raise the funds and this, along with a certain apathy on the part of the committee, held back construction by a considerable time. Local people were indignant about the delay and its causes! (7273)

The original Keble Memorial Schools building and gateway in the early twentieth century. The Keble Memorial Schools opened on 27 March 1889 and were founded by the Community of the Sisters of the Church. They were named after an Anglican priest, poet, academic and religious reformer John Keble (1792–1866). The school originally took 150 boys, 180 girls and 250 infants. In 1955, it was reorganised into a junior mixed school and an infants' school. Both schools were extended and modernised in 1973. The present John Keble Primary School was formed by the amalgamation of the junior and infants' schools in 1984. (1161)

A postcard view of Manor Park Road in the early twentieth century, with terraced houses on both sides, a cobbled road surface in the foreground and a pillar box to the left. The view shows a wide, almost boulevard-like road layout, giving an impression of desirable spaciousness. Harlesden Working Men's Club, founded in 1909, was situated at no. 154 but moved to 61 Craven Park Road in about 1919. (1133)

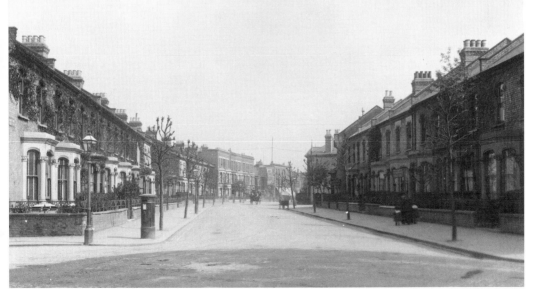

Kindergarten Class-room Convent of Jesus and Mary, Willesden

Kindergarten classroom of the Convent of Jesus and Mary School, showing a small classroom with an abacus to the left, the teacher's desk in the foreground and a statuette of an angel at the back in a bay window. The manufacturer's address includes a postal district number, so the card dates from 1917 or later, though the photograph itself may predate this. The Convent of Jesus and Mary was initially a private boarding school for girls which opened in 1886. Buildings were erected in 1887–8 and 1891–6, and a chapel in 1929. A sixth form was created in 1933. (1494)

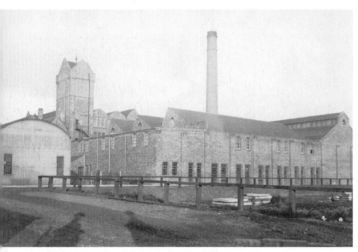

This early twentieth-century postcard entitled 'Willesden Junction' shows the McVitie & Price biscuit factory at Waxlow Road, on the Harlesden/East Twyford border. McVitie & Price opened their Edinburgh Biscuit Works here in 1902, the name referring to the firm's origins in the Scottish capital seventy-two years earlier. In 1919 the factory employed 1,150 people. Jaffa Cakes were created here in about 1927. (1174)

An interior view of St Matthew's Church, in St Mary's Road (known as St Matthew's, Willesden), looking west from the altar, post-1901. The church was founded by the London Diocesan Home Mission in 1894 and was formed from St Mary's and All Souls' parishes. The Bishop of London consecrated the first stone on 12 October 1901. St Matthew's parish hall did service as a forty-bed hospital for wounded servicemen in the First World War. From its earliest days, the church always worked very closely with local schools, and Sunday schools were held in Leopold Road and Oldfield Road junior schools. (1100)

The National Bank Limited on Craven Park Road, *c.* 1907. A ceramic plaque on the front of the building, not yet in evidence in this photograph, reads: 'THE NATIONAL BANK LIMITED THIS BRANCH WAS OPENED ON 17TH. JULY 1882 AND WAS THE FIRST JOINT STOCK BANK IN THE WILLESDEN DISTRICT'. The original Harlesden police station was just out of shot to the left, while Harlesden Presbyterian Church (today St Margaret's & St George's United Reformed & Moravian Church) is just out of shot to the right. Note the tram stop to the left, which reads 'CARS STOP HERE ON REQUEST'. (1148)

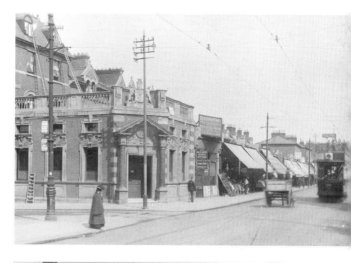

The Elm Tree pub, High Street, 1961. This pub started out as a beer house before 1867. Beer houses flourished after the 1830 Beer-shop Act allowed any householder assessed on the poor rate to sell beer from his house if he paid the licensing authorities 2 guineas. The Act was intended to discourage the sale of spirits, especially gin. The Elm Tree was rebuilt in 1928 by the architect Nowell Parr. It closed after a police drugs raid in 2004 and is now shops, becoming another victim of the general hecatomb of pubs in Brent. (131)

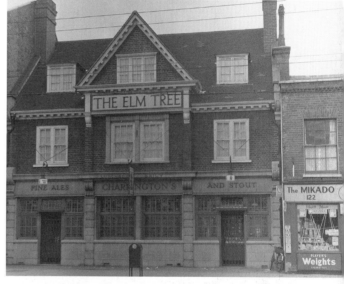

Boots Cash Chemists, 59 High Street, Harlesden, 1930. The manager, Mr Robert Owen, was a relative of the Haynes family of Alperton. (8880)

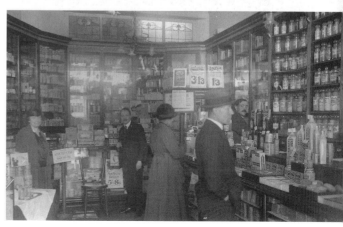

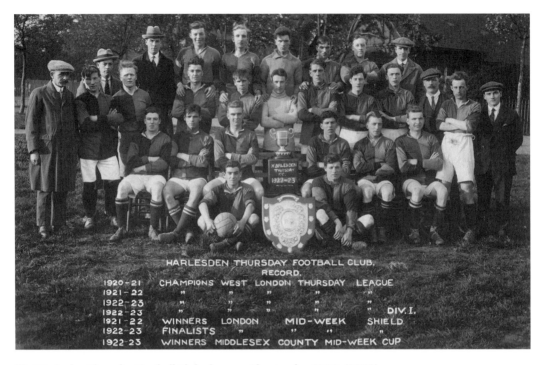

The Harlesden Thursday Football Club players with a trophy, 1923. (9043)

Girls from Leopold Road School learning how to be housewives, or domestic servants, 1930s. In 1936 average attendance at Leopold Road was 550 seniors and 400 infants, 300 fewer than its planned capacity when it had opened in 1897. This photograph is stylistically similar to the photograph of Wembley fire station shown earlier. Could they be by the same photographer? (3036)

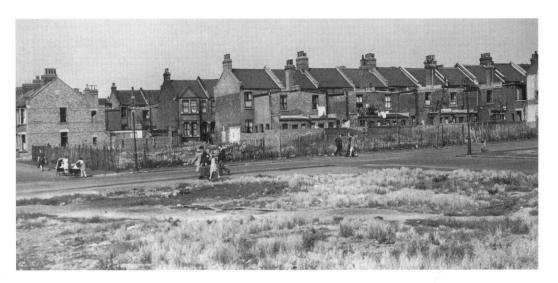

A bombed area after the debris had been cleared, *c.* 1945. These derelict areas were often turned into 'adventure playgrounds' by local children. Many people made homeless by wartime bombs were rehoused in 'prefabs' between Longstone Avenue and Harlesden Road which existed until the 1970s, when new flats were constructed. (9684)

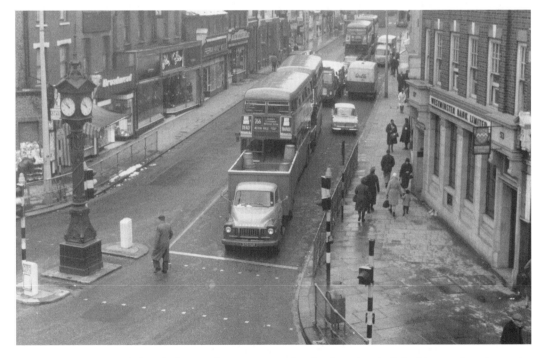

The High Street and Jubilee Clock in early 1964. Note that by then the clock had lost its four decorative lamps, one of which had been torn off by a tram in the early twentieth century! Simpler replacements can be seen in 1930s photographs, but these too had gone by the time this picture was taken. This may have happened in 1938, when the clock was moved at least 10ft from its original position. It was renovated in 1992 and 1997. (150)

The café in Roundwood Park, early 1960s. Roundwood Park opened in 1895, on land near Roundwood House. A 'refreshment chalet' was added in 1897. It was initially run by an A.L. Guionnière. By the 1950s the chalet was in a sorry state, and this photograph shows the replacement café, a small wooden building that was opened in 1958 and, famously, was once run by the self-styled Countess Romanov. (7430)

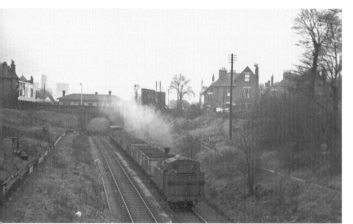

Craven Park, looking south, as one of London's last coal trains on the Dudding Hill loop line returns empty from Kensington to Brent sidings on 3 March 1963. The building on the bridge is the former Harlesden (Midland) station, now largely demolished. Previously called Harrow Road, then Stonebridge Park, it was opened by the Midland Railway in 1875. Situated on the south side of Craven Park Road, the station stopped serving passengers in 1902. This is another photograph taken by Tony Travis. (8501)

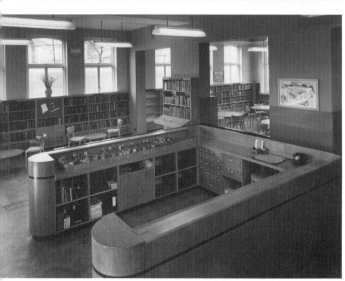

A view of Harlesden Branch Library reception desk after modernisation, 1953. The library was built by the architect John Cash (1858–1926) who also designed Beverley Reference Library, and celebrated its centenary in 1994. Although the building had been modernised several times, as this photograph illustrates, a new Harlesden Library Plus reopened, after an ambitious refurbishment, in September 2009. (9679)

NINE

KENSAL

Kensal Green is situated on Brent's southern border, on Harrow Road. It is first recorded, as 'Kingisholt', in 1253. The name Kensal was first used in 1550. During the Middle Ages, All Souls College, Oxford, was a major landowner in the area.

By the middle of the eighteenth century there were farms, two larger properties and an inn, called the Plough, which was frequented by the artist George Morland in the 1780s. The later expansion of Kensal brought about the appearance of other inns such as the Case is Altered and the William IV, which was noted for its pleasant bowling green and summer houses.

Development took off with the arrival of the Grand Union Canal in 1801. Canal traffic led to the establishment of a brickworks. During enclosure in 1823, the green was divided up into several small plots, and these had cottages built over them. The famous Kensal Green Cemetery opened in 1832, giving further encouragement to the development of the area. The construction of the London & Birmingham Railway completed the conversion of Kensal from village to London suburb. A station called Kensal Green & Harlesden opened in 1861 on the Hampstead Junction Railway, but was renamed Kensal Green (HJR) when it was moved half a mile to the east in 1873.

Better transport connections gave rise to a four-fold population increase, from 675 to 2,138 between 1861 and 1871. However, the haste with which new cottages were erected resulted in poor sanitation and a degree of urban squalor.

From 1888 a new area of development by All Souls College became known as Kensal Rise and in 1890 Kensal Green station was renamed Kensal Rise. The All Souls development now extends from Kensal to Harlesden. Many new churches had to cater for a growing population. There was also a Lawn Tennis Club from 1906.

Between the two world wars, Kensal's population declined, despite the general overcrowding experienced by residents. In the 1970s, many of the Victorian homes still lacked modern conveniences, but they were eventually renovated rather than being redeveloped. There was Afro-Caribbean immigration from the 1960s, and in the 1980s, Kensal began to attract middle class professionals.

Footpath leading to Kensal Rise in the early years of the twentieth century. This is probably the footpath shown on the 1894–6 Ordnance Survey map, which roughly followed the line of the later Chamberlayne Road. In about 1904, a slump in the housing market seriously affected construction in Kensal Rise. The area between Chambers Lane and the lower part of Chamberlayne Road was still undeveloped in 1914, partly consisting of allotments. This area would not be fully built up until the 1930s. (1289)

Kensal Green Manor House, 1934. This is a view of one of the villas, typically aimed at the middle classes, occupied from 1841–3 by Harrison Ainsworth (1803–82), a Victorian novelist of historical fiction in a romantic style. He had earlier lived at Kensal Lodge, from 1835 to 1841. Ainsworth was a friend of Charles Dickens and some of his famous novels include *Rookwood* (1834) which told the story of Dick Turpin, *Guy Fawkes* (1841), *The Miser's Daughter* (1842) and *Boscobel* (1871). He also produced his own periodicals, *Ainsworth's Magazine* from 1842 to 1853 and later the *New Monthly Magazine*. (2005)

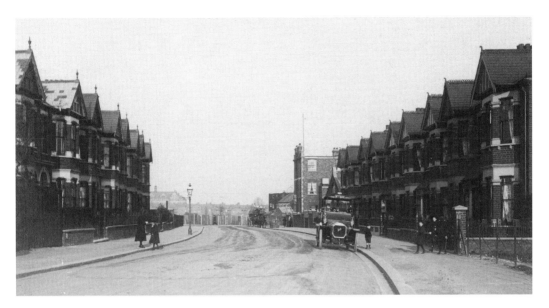

A postcard of the view down Doyle Gardens, showing a slightly curving street of houses with children and a vintage car (licence number H 6111), early twentieth century. Today, Doyle Gardens is the site of Capital City Academy, founded in 2003 on the site of Willesden County School, itself founded in 1924. (1559)

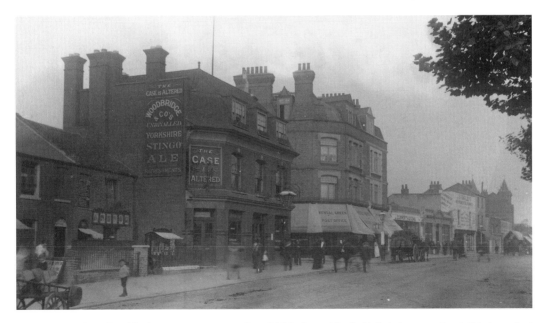

The Case is Altered public house, Harrow Road, *c.* 1908. Surprisingly little is known about this large but relatively short-lived pub, which was situated opposite the gates of Kensal Green Cemetery. The name of the owners is given in pre-1914 *Kelly's Directories*, but the pub is not named. A beer shop had existed here from at least 1843, but it is not known when the pub shown here was built. It was destroyed in an air raid in about 1941. (1584)

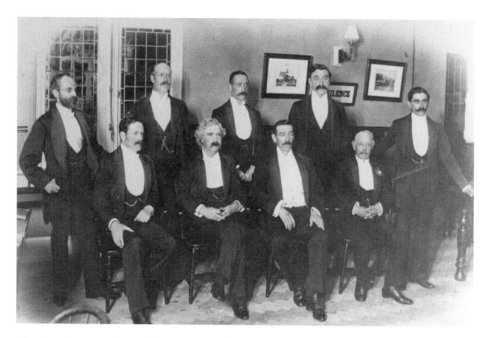

The American novelist and humourist Mark Twain (1835–1910) and the Willesden Library Committee at Kensal Rise Reading Room, Bathurst Gardens, 27 September 1900. Twain officially opened the reading room. He is best known for his characters Tom Sawyer and Huckleberry Finn, and the identity-swapping tale *The Prince and the Pauper*. He is also associated with Brent through his love of Dollis Hill House, which is the subject of a book by local historian Hamilton Hay. (2365)

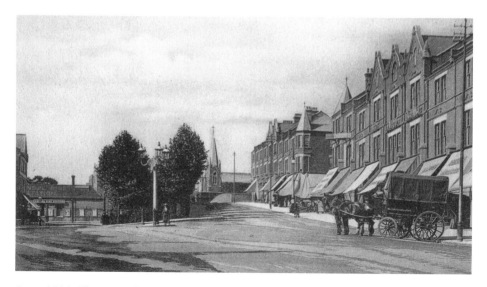

A pre-1914 Allnutt & Hillman postcard of the Exchange, Kensal Rise, showing the old Kensal Rise station with its name written on its roof. The spire belongs to Kensal Rise Wesleyan Church, which is now the Roman Catholic Church of the Transfiguration. The triple lamp standard can still be seen. (7984)

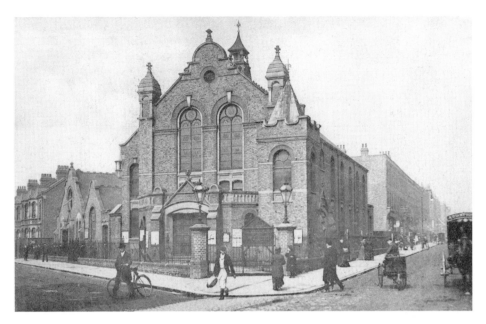

Kensal Rise Baptist Tabernacle, at the junction of Chamberlayne Road and Buller Road. The church opened in about 1894. Designed to accommodate 900 worshippers, its membership had fallen to 74 in 1977–8, partly because of competition from other Baptist congregations. It has, however, managed to remain a cornerstone of local Baptist life. Many current worshippers are of Afro-Caribbean heritage. This postcard was published by F.W. Bridge and is postmarked 6 October 1905. (1554)

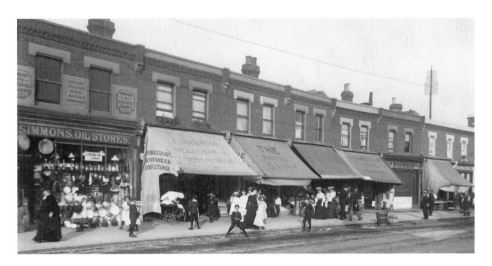

St James's Terrace, Kensal Green, late summer 1904, with the sort of mischievous boy who must have been the bane of postcard photographers. This card is interesting because one can date it relatively accurately, rather than simply relying on a postmark. When magnified, the newsvendor's placard under the awning of Lockwood's stationers reads 'JAPANESE CAPTURE ANPING – LATEST CRICKET'. This dates the photograph to late August 1904, when General Tamemoto Kuroki's 1st Army took Anping during the Russo-Japanese War. (1581)

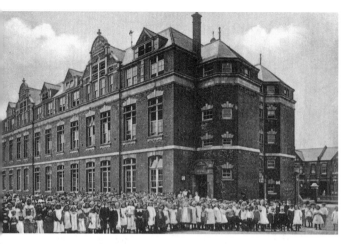

Chamberlayne Walk School, Kensal Rise. The school opened in 1904 as a council school. All the schools in the Kensal Rise area had opened by 1913. This postcard was printed in Germany, as were many other postcards before the First World War. (8025)

Belgian refugee pupils, King Albert Belgian School, 1916–17. By late 1915 Belgian refugees with young children were worried that they were forgetting Flemish and French and adopting English. In February 1916 Willesden Council agreed to open a Belgian school, partly funded by the Belgian government. It was placed in the Sunday School building of the recently built Brondesbury Park Congregational Church, Wrentham Avenue, Kensal Rise. The school opened on 3 April 1916. Lessons were conducted in English, French and Flemish. This photograph was one of a series taken by Mr Arthur Dunn and placed in an album that was presented to King Albert by Willesden Education Committee. The school closed at the end of March 1919. (2332)

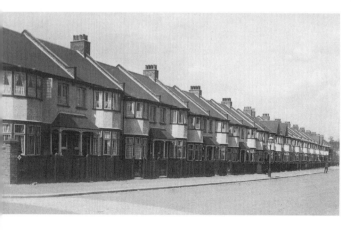

King Edwards Terrace, Kensal Rise, NW. This postcard, depicting relatively modern-looking houses, probably predates 1917, when postal district numbers were introduced, and may date from about 1910. (1573)

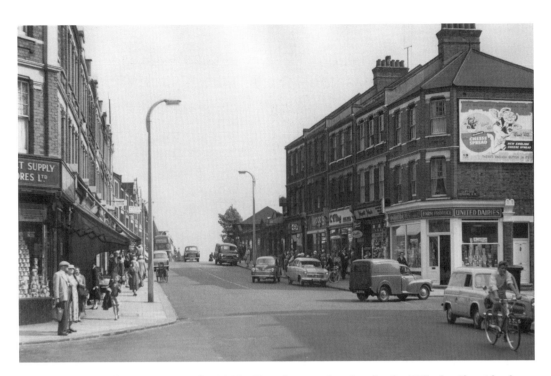

Chamberlayne Road street scene in the 1960s. This photograph, taken for the *Willesden Chronicle*, shows Kensal Rise Bridge with traffic and pedestrians. Chamberlayne Road, connecting Kensal Green with Willesden, was part of All Souls College's development of the area. It became, and remains, a pleasant little shopping centre. (6508)

First Communion at Kensal, 1960s. This photograph was taken at Our Lady of the Holy Souls, Hazlewood Crescent, Kensal New Town, which is outside Brent. However, it was taken by Paddy Fahey, who lived in Brent, and it is also likely that some of the children came from the borough. (6367)

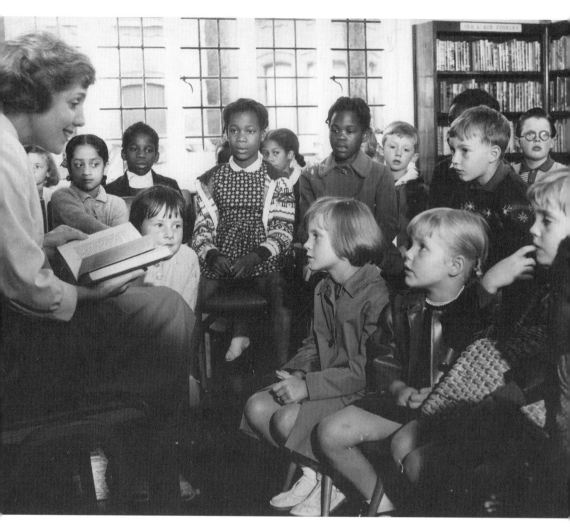

Storytime at Kensal Rise Library in the early 1960s. The session was led by the Children's Librarian, Joan Ablett, and intended for children aged between five and seven. The photograph was taken by Edgware Studios for Brent Libraries. (9039)

TEN

KILBURN

Kilburn straddles the south-eastern border of Brent, where the Roman Watling Street (Edgware Road) crossed the Kilburn Brook. It may take its name from the Saxon for 'cattle stream'. The earliest inns in Kilburn, for example the Cock, appeared in the fifteenth century. Kilburn acquired fame as the site of a spring, near the Bell. By 1733, it was the source of a cure for stomach ailments. The healing water was still being sold up to the 1840s and the Bell (which had been called 'Kilburn Wells') remained popular as a tea garden thereafter. Kilburn was also notorious for duels in the late eighteenth century, but was described as rural and tranquil in 1814.

The London & Birmingham Railway was built through Kilburn in 1837 and a station opened in July 1852. Public transport provision was completed by the Underground railway, which came to Kilburn with the opening of Kilburn Park station in 1915.

Kilburn was rapidly built up in the nineteenth century. In 1857, builder James Bailey began the Cambridge Gardens Estate near Kilburn Park. The population surged from 3,879 to 15,869 between 1861 and 1871. This led to divisions between the urban south of Willesden parish and the more rural north.

Tile-making was the earliest local industry, followed by brick-makers and a windmill. By 1890, there were also coachbuilders, bicycle manufacturers and a railway signal factory. Light engineering and printing were well established by 1914.

This part of Edgware Road was named Kilburn High Road in the 1880s. It would eventually boast more than 300 shops. The largest cinema in Britain, the Gaumont State, opened in 1937 and is now used by an independent church.

The Brent side of Kilburn suffered more damage during the Second World War than the Hampstead side. After the war, industry was reduced and overcrowded or substandard housing in South Kilburn was replaced with flats. Families were rehoused in the new South Kilburn Estate near Carlton Vale, which was completed in about 1970. Construction offered employment to Irish immigrants and, with the arrival of an Indian community, Kilburn gained a Hindu temple.

Attempts at regeneration have been more successful in Kilburn than elsewhere, and the Tricycle Theatre has really put Kilburn on the cultural map.

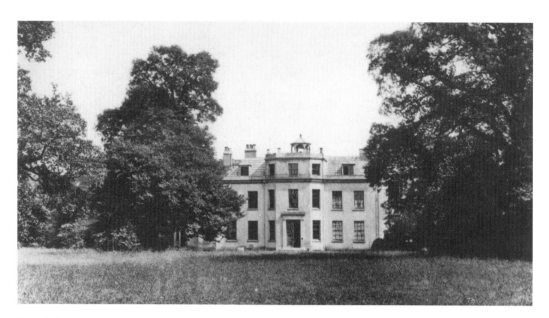

Brondesbury Manor House in the 1880s. The part of Kilburn that was in the parish of Willesden belonged to the manors of Bounds, Brondesbury and Mapesbury, which in medieval times were all owned by St Paul's Cathedral. Brondesbury remained underdeveloped even in 1896, but Brondesbury Manor House finally fell victim to the developers in 1934. (9764)

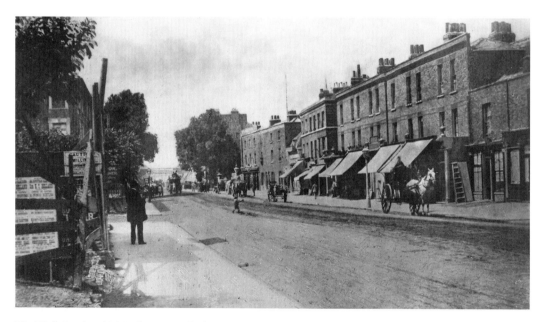

The High Road in 1886. This view is looking north towards Brondesbury station and there are horse-drawn carriages and a parade of shops to the right. The Hampstead Junction Railway opened Edgware Road (Kilburn) station in 1860 which was later renamed in 1883. This was joined by the Metropolitan Railway's Kilburn & Brondesbury (today Kilburn) station in 1879. In 1866 the parish of Christ Church, Brondesbury, was the first new parish to be formed within the original parish of Willesden. (219)

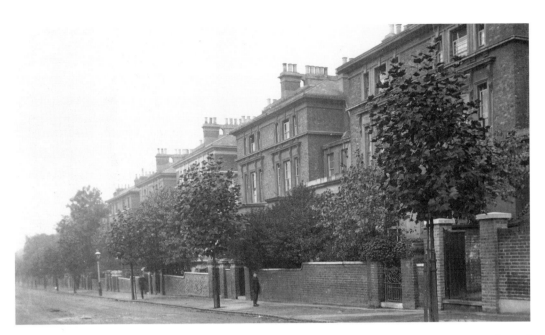

Brondesbury Villas, a Bell's Photo Company Ltd postcard from the early twentieth century. The elevated site at Brondesbury was thought to make the land suitable for the better kind of villa and, in the 1860s, the first entirely new suburban development in Willesden parish was begun here. (1653)

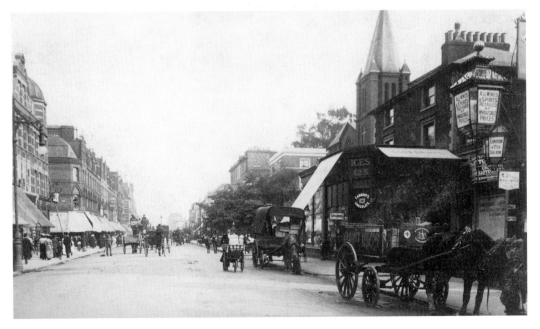

The High Road, looking south before 1914, with the lamps of the Cock Tavern to the right. The spire belongs to St Paul's, Kilburn Square, demolished in 1935. The Rawlings' cart appears to be delivering lager to the Cock, which also displays an early advertisement for 'Löwenbräu Munich Lion Brew Lager Beer'. Note the street sweeper in the left middle distance. (1590)

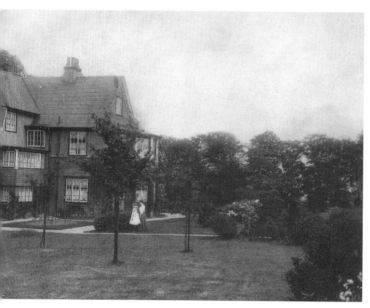

Rose Dene (sometimes given as 'Rosedene'), Christchurch Avenue, Brondesbury, in the early years of the twentieth century. The house, situated on the north side of Christchurch Avenue, four houses south-west of the junction with Brondesbury Park, is first mentioned in 1904. It belonged to Ellis Thomas Powell, LLB, BSC, FRHists (1869–1922), a journalist, barrister and spiritualist. Powell was an active member of the British College of Psychic Science and a close friend of Sir Arthur Conan Doyle. (9788)

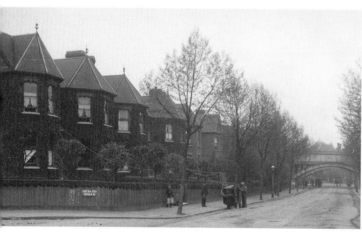

Christchurch Avenue, with the railway bridges at Kilburn & Brondesbury (since 1950 just Kilburn) station in the distance, pre-1914. The junction with Chatsworth Road can be seen to the left. The attractive villas have been replaced by modern flats. (1479)

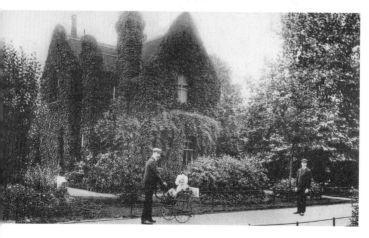

A postcard published in the HRM Series, showing the ivy-covered lodge building in Queen's Park, pre-1914. Queen's Park opened in 1887 and has always belonged to the Corporation of London. Unusually, it is a man who is shown taking the baby out for some fresh air, rather than the housewives or nannies who appear on most postcards. (1627)

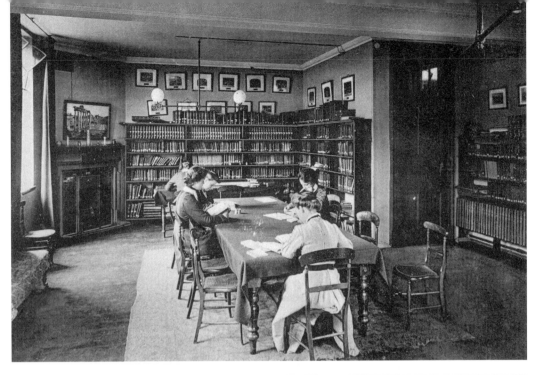

Students studying in the library of the Maria Grey Teacher Training College, early twentieth century. In 1878, Mrs Maria Grey established a Teachers' Training and Registration Society in Bishopsgate for training women teachers. It moved to new premises in Salusbury Road, Brondesbury, in 1892. The new address housed the Teacher Training (later Maria Grey) College, a kindergarten and Brondesbury and Kilburn High School for Girls, which was intended as a demonstration school for the training college. Willesden Urban District Council and Middlesex County Council aided the school from 1909, and it was taken over in 1938 by Middlesex County Council as a grammar school for girls. This building now houses the Al-Sadiq and Al-Zahra Islamic School. (7945)

Willesden Urban District Council fire station, Salusbury Road, in the early twentieth century, with cyclists, children and men in uniform all visible. The station had opened in 1894 to serve Kilburn. The two children turn up in another view of Salusbury Road and were presumably following the photographer around. Photographers were a novelty, and frequently attracted groups of children. (1599)

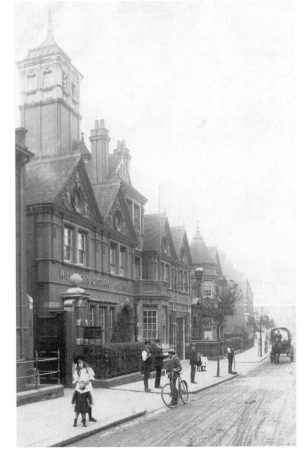

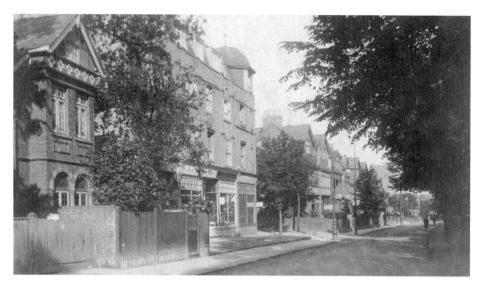

Houses and a row of shops in tree-lined Willesden Lane, pre-1914. Some houses had been built at the Brondesbury end of Willesden Lane as early as 1847. By the 1880s Kilburn had a good mix of shops, a number owned by foreign nationals. Some of these were Jewish immigrants fleeing pogroms in the Russian Empire. Willesden Lane had a significant number of immigrant-owned shops. During the anti-German rioting that followed the sinking of the *Lusitania* in 1915, one Willesden Lane shopkeeper displayed his Russian passport in the window to protect his premises from attack. (1507)

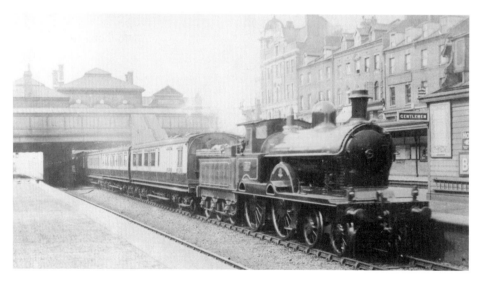

An Up passenger train at the London & North Western Railway Company's Kilburn station, hauled by what looks like a 'Precursor' class 4–4–0 locomotive. Today called Kilburn High Road, the station had opened in July 1825. None of Kilburn's railway stations played much of a role in stimulating development. This photograph was not taken in Brent, but the rear of the train crosses the boundary into Willesden. (9749)

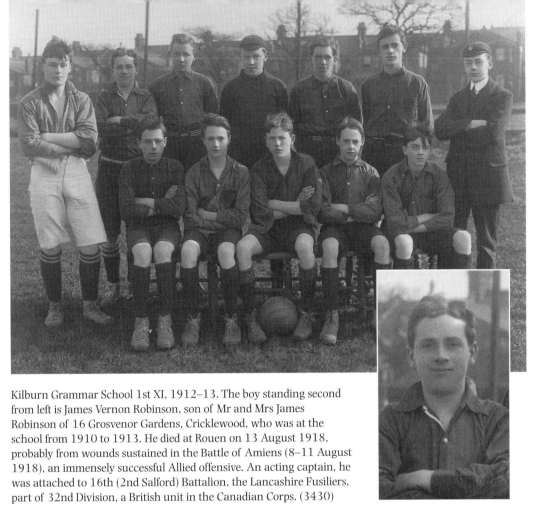

Kilburn Grammar School 1st XI, 1912–13. The boy standing second from left is James Vernon Robinson, son of Mr and Mrs James Robinson of 16 Grosvenor Gardens, Cricklewood, who was at the school from 1910 to 1913. He died at Rouen on 13 August 1918, probably from wounds sustained in the Battle of Amiens (8–11 August 1918), an immensely successful Allied offensive. An acting captain, he was attached to 16th (2nd Salford) Battalion, the Lancashire Fusiliers, part of 32nd Division, a British unit in the Canadian Corps. (3430)

Patients and nurses at Brondesbury Park Military Hospital annexe during the First World War. The hospital was founded in 1915 in the Roman Catholic Mission House situated on the north-east side of Brondesbury Park, between The Avenue and Christchurch Avenue. The building was given by Father Herbert Vaughan. On 19 May 1917 a new wing was opened in Beversbrook, another large house, located directly across the street. This had previously been used as a hostel for Belgian refugees. The men in this photograph were presumably patients at Beversbrook. The hospital, which published a magazine called *With the Wounded*, closed on 15 November 1919, having treated 2,700 patients. Beversbrook later became a nursing home. (8237)

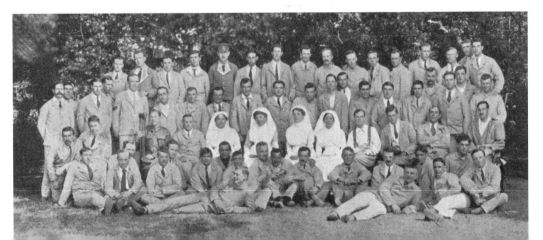

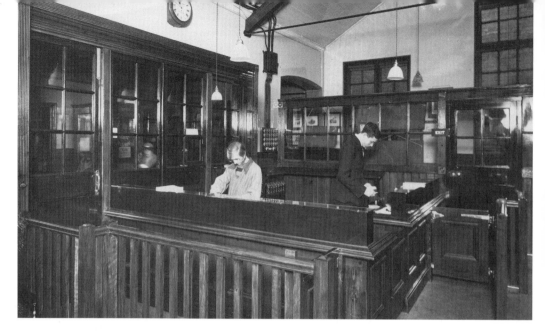

The interior of Kilburn Library after its conversion to open access in 1928. Prior to this date, users looked up books in a catalogue and the staff then fetched the volume for them. The library had opened on 3 January 1894, in the same year as Willesden and Harlesden libraries. The Willesden Local Board had formally adopted the Public Libraries Acts on 24 February 1891. The library building was extended in 1907. Its existence is owed to the campaigning efforts of a Mr W.B. Luke, a prominent member of the local board. (9760)

Brondesbury & Kilburn High School for Girls sixth formers, 1927. In the late 1920s and early 1930s there were accommodation problems at BKHS. Interviewed in 1967 for the 75th anniversary issue of the school magazine, Joan Charlesworth, who left in 1934, recalled 'sixth form lessons were held in all sorts of odd places', including on landings and, in good weather, on the roof. This photograph seems to document this. (3140)

The meeting room of Willesden Borough Council, Willesden Town Hall, Dyne Road, May 1955. Originally the offices of Willesden Local Board, this building opened in 1891. Most of Willesden's municipal buildings were erected in the 1890s. Willesden was a Labour-controlled authority from its inception in 1933 until 1964–5. When Brent was created, Wembley Town Hall became the new council's headquarters. Willesden Town Hall was demolished in 1970. Dyne Road was named after Dr J.B. Dyne (1809–98), a fellow of Wadham College, Oxford, headmaster of Highgate School and Prebendary of Mapesbury. (435)

Waterloo Passage, Willesden Lane, 1950s. The buildings to the right are on Kilburn High Road. The name presumably comes from Waterloo Cottages, seven large houses built along the west side of Edgware Road by a Thomas Buckley in 1815. They were inhabited by wealthy and professional people, but were demolished in 1885. Waterloo Passage ran parallel to Kilburn High Road where their front gardens used to be. (390)

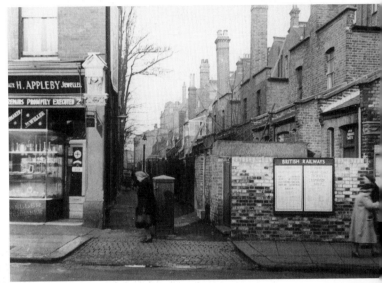

Houses scheduled for demolition in Albert Road, South Kilburn, 1950s. After the war the Greater London Plan called for the replacement of overcrowded slums with flats. This started in 1951 in Kilburn Vale, and a few years later in South Kilburn, where average population density was ten people to a house and some houses were actually falling down. Today, Albert Road consists entirely of flats, some of them quite modern, and is graced by a number of trees. (2995)

The demolition of houses in Alpha Place, South Kilburn, *c.* 1950. Houses in Alpha Place had been obtained using a Compulsory Purchase Order as early as 1934. In 1952 work began on Alpha House, the first phase of a project that went on to include Gorefield House and Canterbury Court. This photograph could easily be mistaken for a view of damage caused during the Blitz. (6482)

Peel Precinct, Carlton Vale, photographed by John McCann, post-1963. This purpose-built shopping centre was opened in 1963 as part of the South Kilburn Redevelopment Scheme. The Sir Robert Peel public house, previously a mid-1860s building, is to the left, with a block of flats called Craik Court behind it. This was named after authoress Mrs Craik, who lived in the White Horse, Church Road Willesden, and nearby Hampstead. Her best known novel, *John Halifax, Gentleman*, was published in 1857. The planned area of reconstruction for South Kilburn extended from Carlton Vale to the railway line beyond Albert Road, with Neville and Rupert Roads on either side. It involved the partial demolition of Canterbury Road. (54)

The seventeen-storey 'pocket skyscraper' at Kilburn Square, seen from Victoria Road, June 1964. This photograph was published in the *Willesden Chronicle* for 12 June 1964 under the headline 'Tower of their dreams'. According to the accompanying article, the new council block, which had cost over £1million, pleased 'everyone who lives inside the gleaming new pile', despite teething trouble with the lifts. One of the residents was Mrs Rainbird, a former Mayoress of Willesden. (236)

ELEVEN

NEASDEN & DOLLIS HILL

Neasden is in the middle of Brent and borders many other of the borough's districts. Its name means the 'nose-shaped hill' in Anglo-Saxon. St Paul's Cathedral owned land there in about 1000. By the Middle Ages, the village had several small buildings and a green.

During the fifteenth century, the Roberts family were the dominant landowners, building Neasden House, eventually one of the largest properties in the parish in the sixteenth century. The Roberts were succeeded by the Nicoll family who owned Neasden House by 1818.

When enclosure came in 1823, Neasden had at least four farms, six cottages, a smithy and a public house. In the 1850s, Neasden was primarily a farming community. Railways arrived in 1868, with a station, Dudding Hill, for Willesden and Neasden, following in 1875. In 1880 the Metropolitan Railway extended its line and opened a station on Neasden Lane. The company purchased land for engine sheds and workers' housing, which was called Neasden Village. In 1880, thirty trains a day were running between Baker Street and Harrow and the journey from Neasden to Baker Street took twenty minutes.

The railway drove rapid expansion. The Dudden Hill Estate, planned from 1899, was largely completed by 1911. Owing to rising population levels, the new parish of Neasden-cum-Kingsbury was created in 1885. Social amenities soon followed, such as Neasden Cricket Club.

Light industry started up just before the First World War, with firms such as British Thomson Houston and the Neasden Waxed Paper Company becoming local employers. A shopping centre was built in the 1930s to supply the developing neighbourhood, but Neasden always remained too industrialised to be a proper suburb and was the butt of satire in publications such as *Private Eye*.

New out-of-town shopping centres such as Brent Cross (1976) encouraged buses to bypass Neasden entirely. Industrial decline had a visible impact, but Neasden's survival was ensured by more recent immigration, the opening of some new pubs on the high street and the building of the truly impressive Swaminarayan Mandir Hindu Temple in 1995.

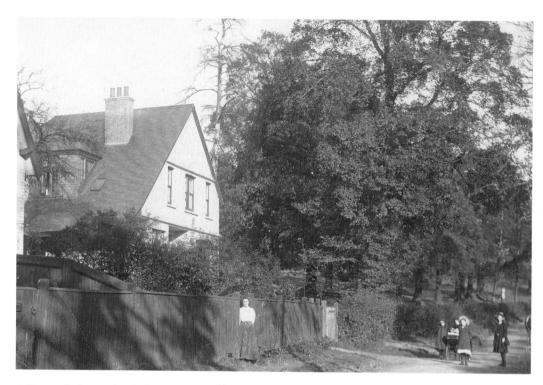

A Reeves Series postcard showing a rural-looking Dollis Hill Lane, with housing to the left, in the early twentieth century. A woman is standing by the entrance to her garden, with children standing in the lane. Dollis Hill, named after someone called Dolley or Dawley, is first recorded as a settlement in the late sixteenth century, but the earliest evidence of settlement in the area dates back to the early Iron Age. (1275)

Mushrooms being grown on the Neasden allotments, April 1898. (9669)

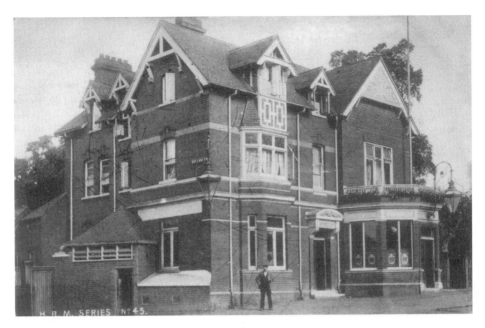

The Old Spotted Dog, before 13 August 1907. There was a pub in Neasden as early as 1422. The Spotted Dog may have been known as the Angel before changing its name in about 1767. Willesden vestry held parish dinners here. By the 1870s it was 'a sort of suburban tea-garden' attracting Londoners. The pub in the photograph was built in 1880. In 1932 it was again rebuilt, as a very imposing mock-Tudor road house. This was demolished in 1997, losing Neasden's drinkers a pleasant and spacious pre-war interior. (8023)

Workers and locomotives at Neasden Metropolitan depot, sometime between 1905 and 1922. In 1880 the Metropolitan Railway extended its line from Willesden Green to Harrow. It also purchased 290 acres (116 hectares) of land to build workshops, engine sheds and labourers' cottages. The two engines are examples of both electric locomotive designs ordered by the Metropolitan in 1904. Ten of these were a boxcar design by BTH and ten others a centre-cab design by British Westinghouse. The engine in the foreground here is a BTH example. They were replaced by Metropolitan Vickers locomotives in 1922. (2708)

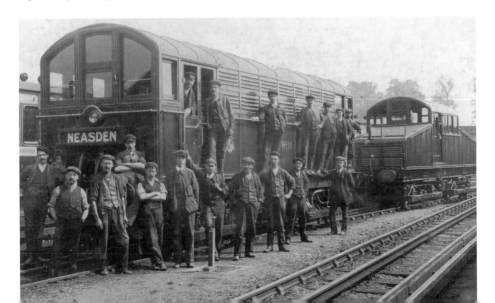

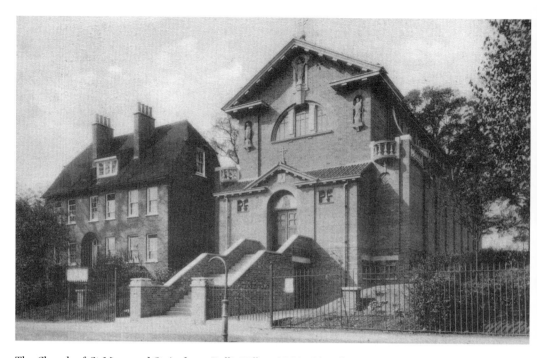

The Church of St Mary and St Andrew, Dollis Hill, *c.* 1933. After the opening of St Andrew's Hospital in 1913, Dollis Hill's Roman Catholics could attend mass in its chapel. As numbers increased, they moved to a wooden church in the hospital grounds, which became the centre of the parish of St Mary and St Andrew in 1927. The church here, designed and built by Francis Butt, opened on 18 May 1933. Note the peculiar piece of street furniture on the kerb. These turn up all over Willesden in early twentieth century postcards, but their purpose is a mystery. It may be that they were intended for watering horses. (8242)

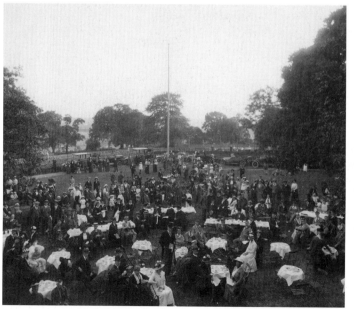

A sepia photograph of a garden party to raise money for wounded soldiers in Willesden hospitals, held at Dollis Hill House, 1915. This was probably taken on 25 June 1915, when the *Willesden Chronicle* reported a fund-raising concert at the house. Dollis Hill House itself later became a military hospital, opening on 22 July 1916. This view looks across the gardens from an elevated position, perhaps an upper window. Note the wounded soldiers in their 'hospital blues', and the charabancs and cars lined up along the rustic fence which encloses the lawn. (9060)

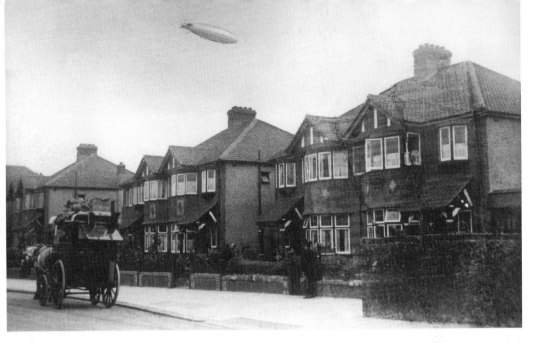

The ill-fated *R101* airship over Burnley Road, Dudden Hill, late 1929 or 1930. When completed in October 1929, *R101*, based at Cardington, Bedfordshire, was the world's largest flying machine. In June 1930 she visited the Hendon air show. A few seconds after 2.04 a.m. on the morning of 5 October 1930, en route to Karachi, *R101*'s outer covering tore in a storm. Just 4 minutes and 38 seconds later the airship crashed into a hillside near Beauvais and burst into flames. Forty-eight people died and Britain gave up on airship design altogether. (2607)

A *Willesden Chronicle* photograph from the opening of Neasden Library, 1931. Neasden Library came much later than other social provisions in Willesden, but had a very pleasant reading room overlooking the Welsh Harp Reservoir. (9723)

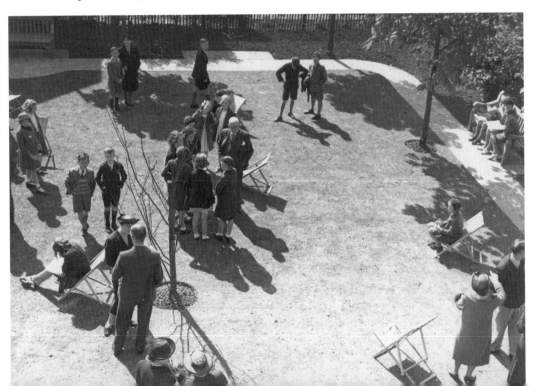

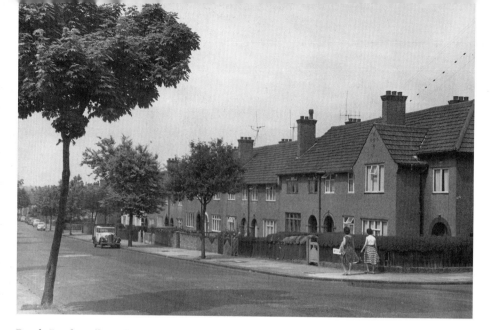

Brook Road, Dollis Hill, before 30 June 1961. A rather old-fashioned car is parked in the middle distance, and a surprising number of vehicles are parked further down the street. This was taken just to the left of Brook Road's junction with the modern Ainsworth Close (named after Harrison Ainsworth, see Kensal chapter). Brook Road was also the location of the GPO Research Station and a secret wartime bunker, where Churchill's cabinet met twice during the Second World War. (32)

Neasden Lane, early 1964. This photograph was published in the *Willesden Chronicle* for 13 March 1964 to illustrate an article promoting Neasden shops. The double-decker bus in the foreground is being used as a Green Line coach. (267)

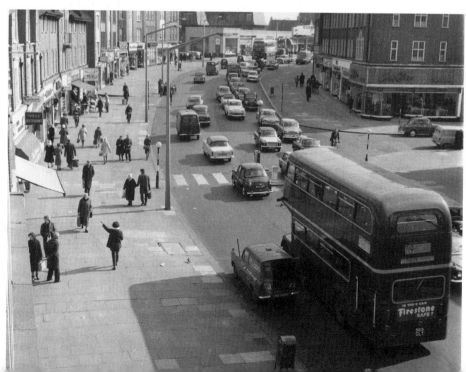

St Andrew's Hospital, Dollis Hill, 1963. This photograph appeared in the *Willesden Chronicle* for 8 March to mark the hospital's golden jubilee. The portion of the building to the left is an extension added in 1952. This private Roman Catholic hospital, initially catering to the 'professional and middle classes', opened on 26 September 1913. It was financed by a donation from an anonymous French lady, later revealed to be Marguerite Lebaudy, née Piou. Some of its earliest patients were wounded Belgian soldiers. It pioneered plastic surgery in the 1930s, but closed in 1973. (9798)

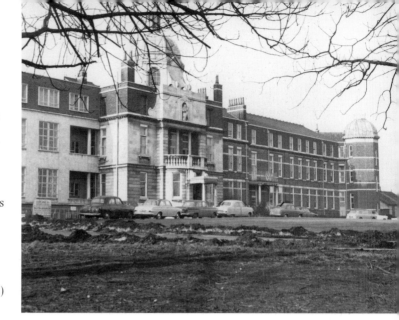

The interior of Allan Collingridge's house, the Grange, Neasden Lane, 1970. This house became the Grange Museum in 1976. Between 1700 and 1708 a Thomas Wingfield built a property called the Grove, facing Neasden Lane. Allan Clive Collingridge (1900–72) was the last inhabitant of the Grange, an outbuilding (probably the stables) of the Grove. Collingridge was an Oxford graduate and a promoter of adult education, particularly of the unemployed. The door on the right leads into a Victorian extension. (9730)

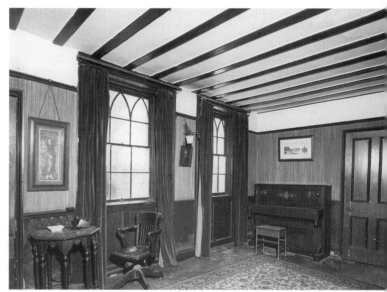

The construction of the notorious Neasden underpass in 1973. Congestion of the North Circular road grew into an intractable problem in the later 1930s and, despite local opposition, traffic on Neasden Lane was diverted by this underpass, which required the demolition of numerous houses and, controversially, bypassed the main shoppong area. (9392)

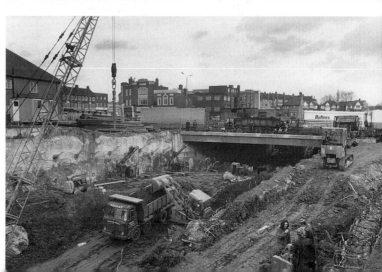

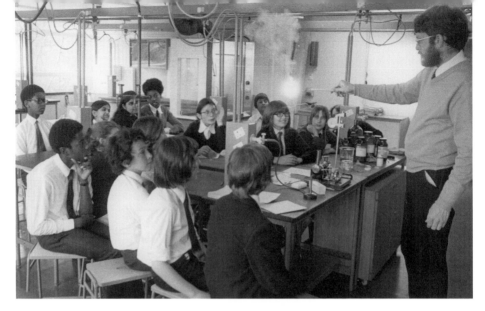

A group of pupils watching a teacher conduct an experiment in the science lab, Neasden High School, Quainton Street, probably 1970s. Neasden High School was partly created to absorb Asian refugee children whose families had been driven from Africa. Built on the site of the Metropolitan Railway's power station, it was reputedly one of Britain's fastest-built school buildings. It was opened in 1973 by *Private Eye*'s Willie Rushton, who had released a comic song entitled 'Neasden!' the year before. A new library was added in 1986, but the school was closed and demolished only three years later. (3051)

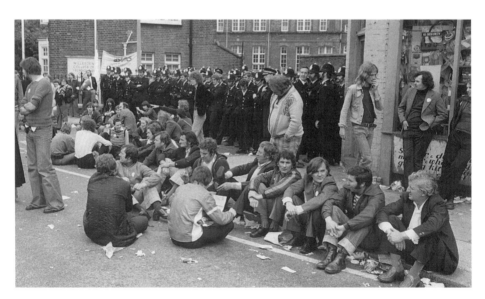

Pickets and police at Cooper Road during the Grunwick dispute, Dollis Hill, 1977. In August 1976, the dismissal of a young man at the Grunwick photo-processing factory in Chapter Road began an acrimonious industrial dispute about trade union recognition that developed into a *cause célèbre* for both left and right, giving it far more than local significance. Most of the strikers were Asian women, led by Jayaben Desai who died in January 2011. Despite mass picketing by sympathisers in 1977, the strike was unsuccessful. It lasted 670 days. Cooper Road was situated west of the Chapter Road premises. A new street off Chapter Road has been named Grunwick Close in memory of the dispute. (8982)

TWELVE

PARK ROYAL

Park Royal is situated in the south of Brent. It was originally known as Twyford, meaning 'place by a double ford'. Park Royal owes its origin to the Royal Agricultural Society's plans to make Twyford the site of a permanent showground. Coronation Road was built to provide access to it. The first show was held in 1903, with a Great Western Railway station called Park Royal opening in time to serve visitors. The show was opened by the Prince of Wales and the site was officially named Park Royal in his honour.

The RAS's showground was not a financial success and they stopped using the site. Queens Park Rangers FC, who had used the horse ring as a stadium from 1904, moved to the GWR's new Park Royal Stadium, playing there from 1907 until 1915. In the nineteenth century a few factories had existed near the Grand Union Canal and Willesden Junction, and aircraft were being assembled in the area even before the First World War. The district became a centre for mushroom farming by 1907, with new farms setting up even after the First World War.

During that war many munitions factories came to the area, one of which employed 7,000 workers, mostly women. After the war, much of the Park Royal site became derelict, but there were forty businesses on the estate by 1920, as wartime industry adjusted to civilian circumstances. The proximity of the railways, and adequate road links, made this industrial area well adapted to import and export, thus providing a ready workforce from recently urbanised Willesden. The Heinz factory came to Waxlow Road in 1925. By the early 1930s, there were seventy-three factories manufacturing a colossal variety of goods and the Park Royal estate was the largest industrial zone in southern England. Even during the Depression of the 1930s, 256 firms were making consumer goods like pens and radios, or capital goods like lorries.

During the Second World War, the focus shifted again to munitions and there were frequent air raids. Prosperity lasted through the 1950s and '60s and at its peak, 45,430 people were employed in Park Royal. Nonetheless, the area was hit by the decline in the British economy that followed. North-west London was particularly vulnerable to this, as the narrow roads were unsuited to large lorries and there were few car parks and facilities for workers. There were huge job losses between 1977 and 1983. Many firms either collapsed or, like Walls and Park Royal Vehicles, moved elsewhere.

By 1987, Park Royal was classed as a depressed area. There were various attempts to set things back on track and there were discernible improvements due to the work of the Park Royal Partnership Ltd, responsible for regeneration in the area. Single Regeneration Budget funding was obtained for 1995–2002, and there are now new facilities such as an Asda superstore and a multiplex cinema.

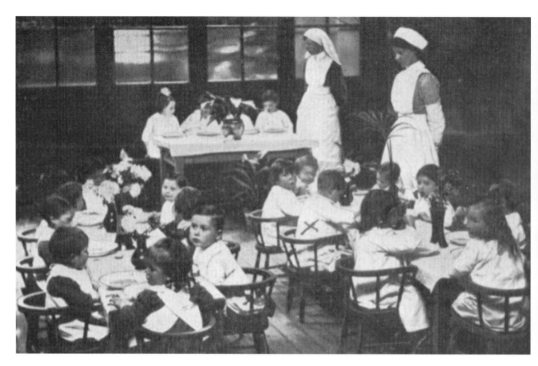

A photograph from a Willesden Urban District Council booklet marking the first anniversary of the Day and Night Nursery, Barrett's Green Road, Lower Place, Acton Lane. It opened on 19 February 1917 to provide childcare for the offspring of munitions workers. It cost 6*d* per child for each twelve-hour day or night session. This image is entitled 'Dinner Time'. (7760)

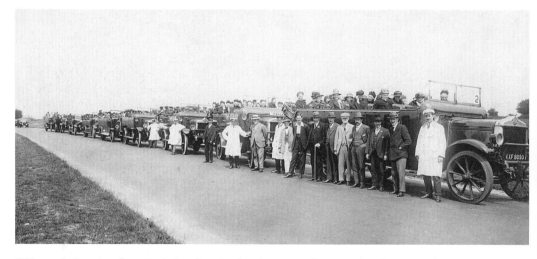

'Old peoples' outing from Park Royal to Dorking', 1928. This is a charabanc trip from the Willesden workhouse (the workhouse system was not abolished until 1 April 1930). The people standing by the lead vehicle are probably members of the Board of Guardians. Called Park Royal Hospital from 1921 to 1930, the workhouse had two pavilions for the aged and infirm, segregated by sex, as are the charabancs here. The workhouse eventually became Central Middlesex Hospital. (9038)

A view of an electrical engineering factory on the Park Royal Industrial Estate, taken in about 1947 by S.A. Newman. (316)

Sister M. Fountain 'treats' Mr A. Rudd, scoutmaster of the 44th Willesden Group, at a first aid exercise at Central Middlesex Hospital, 15 May 1956. The Scouts were simulating casualties to help prepare a Central Middlesex team for a national competition between mobile first aid units, to be held at Friern Hospital, New Barnet, on 26 May. People in the 1950s are sometimes said to have lived in perpetual terror of nuclear war, but the participants here seem to be enjoying themselves. (9799)

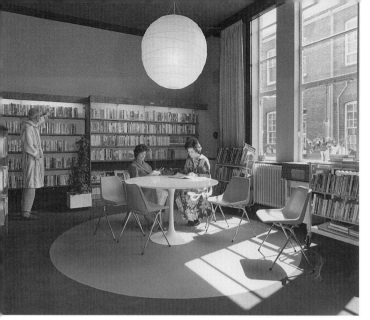

The Central Middlesex Hospital Library, 1975, showing readers in dressing gowns. The photograph was taken by John McCann. Central Middlesex Hospital was first known as the Willesden Workhouse Infirmary and was under the responsibility of the Willesden Board of Guardians, who acquired the land from the Twyford Abbey estate in 1897, and built the institution in 1903. From about 1904, children born there were registered as having been born at Twyford Lodge, to remove the workhouse stigma. In 1930, when it ceased to be a workhouse and was taken over by Middlesex County Council, the name was changed to Central Middlesex County Hospital. This was further simplified after the introduction of the NHS in 1948. (2932)

A lesson at the School of Nursing, Central Middlesex Hospital, 1970s. In the mid-1970s, the North-West Metropolitan Region's Central Middlesex Group School of Nursing, based at Central Middlesex Hospital, had training places for 105 SRN student nurses and 80 SEN (General) pupil nurses per year. The school 'trained the vast majority of nurses who then initially practised in the area.' (9147)

Surplus yeast being skimmed off a fermentation vessel in the Guinness brewery, c. 1953. In the early 1930s a disagreement between the British and Irish governments led the British to encourage Arthur Guinness & Company to build a brewery in England. Designed by Sir Giles Gilbert Scott, also responsible for Liverpool's Anglican cathedral, Bankside power station and the red telephone box, this opened in 1936. It consisted of five buildings, running south to north. The brewing process started in the south in the malt store and ended in the north at the vat house. It was aided by gravity, as the site sloped down to the north. The brewery closed in 2005. (Diageo)

THIRTEEN

STONEBRIDGE

S tonebridge lies in southern Brent, on the Harrow Road between Harlesden and
Wembley. Until 1905, the River Brent used to divide into two just north of the
Harrow Road and the original Stone Bridge (built in the late seventeenth century,
when most bridges were of wood) carried the road over the eastern branch of the river.

An inn called the Stone Bridge dated from at least 1770, but was renamed the Coach
and Horses by 1790. In the mid-nineteenth century, Stonebridge was still a rural location,
although this rapidly changed with the opening of Willesden Junction station in 1866,
which made the place an attractive base for commuters. A private estate flourished,
which became home to many people involved in local government, including the local
historian F.A. Wood, who lived at a property called Hurworth.

Later housing went up to the west of Stonebridge Park, at Melville, Brett and Barry
Roads, but of lesser quality, as these areas were intended for terraces and shops. Hillside
on Harrow Road developed into a major shopping centre and was to remain so until the
1950s. The church of St Michael and All Angels was built in 1891 and was established as
the central parish church by the following year.

In the early twentieth century Stonebridge became more industrial and working class.
By 1914, a brickworks existed next to the railway, and the St Raphael's council estate was
built after the First World War. The 1933 Willesden Town Planning Scheme concentrated
industry next to the estate. After the Second World War, Stonebridge's main employers
were a railway goods depot and a trolley bus garage.

In 1949, the local population peaked at 17,641. There was much overcrowded and
derelict housing and Barry Road was by then regarded as a slum. A plan was devised to
redevelop 98 acres of Stonebridge. Whole streets were wiped out and the shopping centre
at Hillside was also lost. The first high-rise blocks dated from 1967 and, by 1978, there
were several more, alongside a small, modern shopping precinct.

The Stonebridge Estate has not escaped problems over the years, and residents have, at
times, felt neglected and badly housed. Attempts to give a better quality of life to residents
were undertaken by the Stonebridge Housing Action Trust (1994), which offered tenants
more of a voice. Improvements to the estate and local area are ongoing.

Stonebridge Park in the early years of the twentieth century. In the late 1860s a select estate of detached and semi-detached houses was begun in Stonebridge. Initially known as Harlesdon Park, but later called Stonebridge Park, the estate was never as grandiose as its planners had intended, but by 1876 over sixty 'smart new villas' had been built. The piles of leaves indicate that this photograph must have been taken in the autumn. (1156)

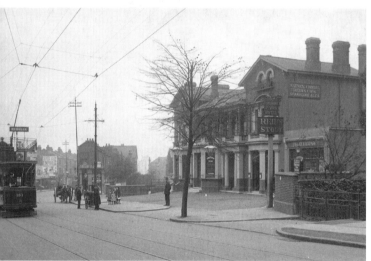

Hillside, with the Stonebridge Park Hotel to the right, sometime between 1907 and 1914. The hotel, built in about 1872, was intended to cater for the middle class residents of the new Stonebridge Park Estate. Working class housing, and shops followed. By 1949 a number of the houses were overcrowded and some were derelict. Willesden Council decided to redevelop the area, demolishing many properties, including all the shops on Hillside, seen in the distance here. The pub, now the Brent Park Hotel, survives, and is Grade II listed. Note the advert for the Shepherd's Bush Empire music hall. (1131)

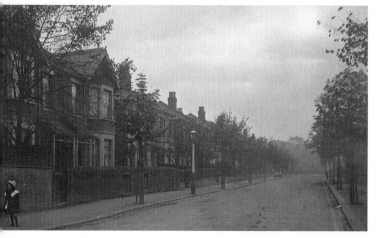

Bruce Road, off Craven Park, a residential street lined with young trees, in the years before the First World War. The girl standing to the left is holding a racquet. (1150)

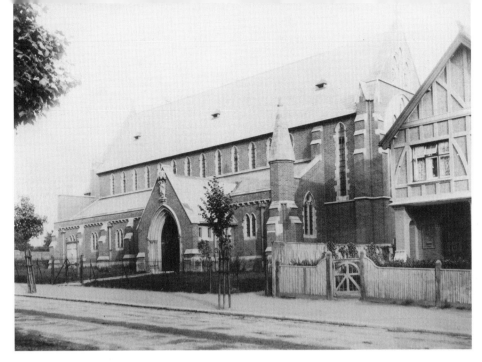

St Michael & All Angels Church, Hillside, pre-1904. Mission meetings began in rented rooms in Stonebridge in 1876. A temporary church was opened in 1886, and a new parish was formed from portions of St Mary's, Willesden, and All Souls', Harlesden, in 1891. This church dates from the same time, but it was never completed to the architect's plan, despite work being renewed in 1904, when a chancel was added. The chancel is absent in this photograph, providing useful dating evidence. (2259)

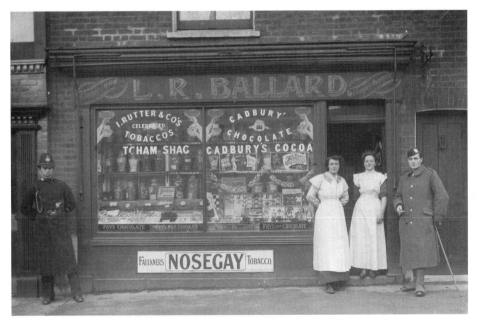

L.R. Ballard's grocer's and confectioner's shop, Orange Tree Terrace, Hillside, during a Christmas in the First World War. One of the decorations in the window shows a rather unseasonal field gun. A soldier, policeman and two female staff are standing outside. (3266)

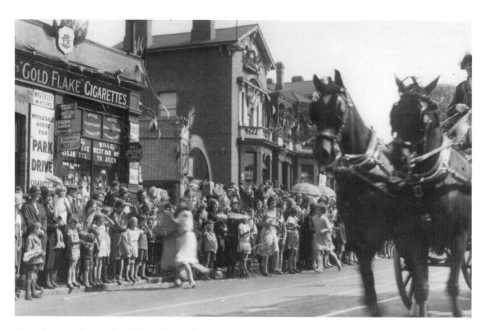

Crowds watching the Willesden Charter Day procession come through Stonebridge on 7 September 1933, when Willesden Urban District Council was given borough status. The charter day celebrations marked the occasion of Willesden receiving its Charter of Incorporation. (9029)

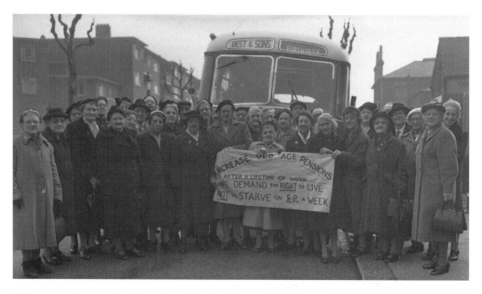

Old age pensioners about to set out for the House of Commons, St Michael's Hall, 17 April 1956. That date was Budget Day, and the pensioners were taking a petition arguing for an increase in pensions. This was Chancellor Harold Macmillan's 'lottery budget', in which he introduced Premium Bonds. We do not know what sort of reception the pensioners got, but, compared to elderly people in most Continental countries, British pensioners continue to get a raw deal under governments of all political persuasions. (9847)

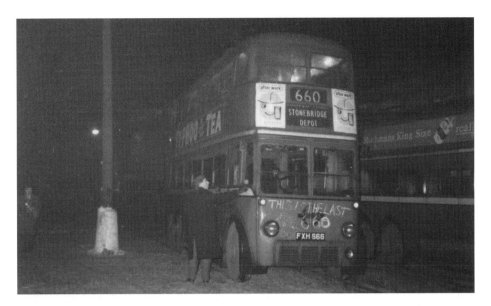

The last 660 trolleybus at Stonebridge Park, January 1962. This was vehicle 1666. Four garages – Colindale, Finchley, Stonebridge and West Green – stopped trolleybus operation on 3 January 1962. Four trolleybus routes were replaced by seven motor bus routes. The last day of trolleybus operation in London as a whole was 8 May 1962. As the snow shows, January 1962 was cold; the temperature at Heathrow fell to -12.8°C. (8985)

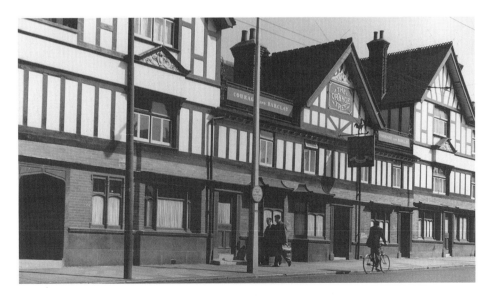

The Orange Tree public house, 32–4 Hillside, 1961. These premises had an early existence as a beer-house from 1835, probably having been built to serve a small group of buildings on the Harrow Road (later Hillside). Joseph Smith was the first landlord. Numerous alterations took place during the late 1890s and early 1900s and it was later extensively restored, but still managed to retain the impression of its humble beer-house origins. It closed down in 2001 and was demolished in 2007. (9030)

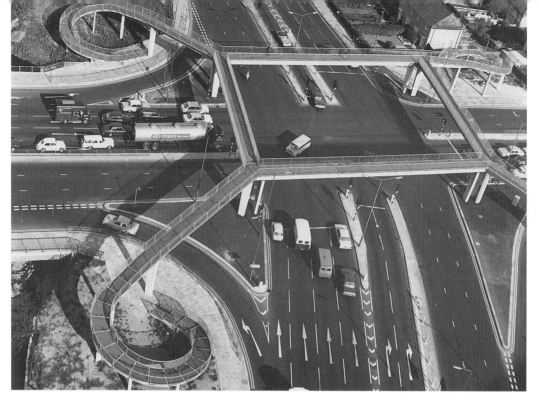

Footbridge, North Circular road, Stonebridge, taken by Michael Beazley in the early 1970s. This is an aerial view of the footbridge at the intersection of the North Circular and Harrow roads. Note the Guinness tanker, a reminder of the nearby Park Royal Brewery. (2534)

Stonebridge Park Estate, stage 1, blocks 1–5, photographed by John McCann in March 1967. The photograph shows the east elevation of Amundsen House (block 4), taken from Shackleton House. All the blocks were named after explorers. Amundsen House, north-east of the Stonebridge Park/Gloucester Close intersection, has fared better than the later blocks of flats on the Stonebridge Estate, south of Hillside, which have been demolished. (361)

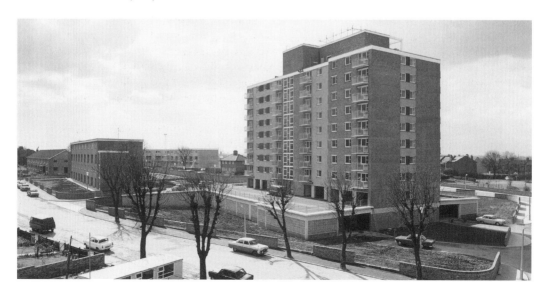

FOURTEEN

WILLESDEN

The name Willesden is possibly taken from the Anglo-Saxon 'Wielldun' meaning 'the hill of the spring'. It is first mentioned in the Domesday Book. Willesden Green was the largest hamlet in the parish of Willesden, set in a woodland clearing. Several houses formed a group around a large village green. The area was entirely rural between the sixteenth and eighteenth centuries, but, by the early nineteenth century, all the woodland had been cleared and most of the land was used for hay farming. After enclosure in 1823 a number of cottages were built around the green, mainly occupied by poorer tradesmen, and some middle class villas appeared in the early 1850s.

The parish of St Andrew's was created in 1880 to serve the larger population, but part of the old green was still visible even in 1907, when the High Road comprised a varied range of shops. Social facilities included a concert hall and Willesden Green Library, built in 1894. Development continued in the form of tram services connecting Willesden with Edgware, Cricklewood and Harlesden. There were thirteen buses an hour running between Willesden Green and Harlesden by 1914. The First World War saw an increase in light industry.

There was considerable Irish immigration to Willesden Green during the Second World War. Many young Irish men worked in local factories, contributing to the war effort. St Paul's Avenue seems to have had a particularly large Irish population by 1943. Later post-war immigration was from the Caribbean, East Africa and the Indian subcontinent. A post-war council plan called for redevelopment on both sides of the High Road, but little was done and Willesden entered a period of commercial decline with regular shop closures, exacerbated by traffic congestion on the High Road and the growth of massive out-of-town stores such as Tesco at Brent Park.

Work started to arrest these trends, resulting in a relatively recent town centre supermarket (now Sainsbury's), while the Willesden Library Centre site continues to be the focus of development as a cultural hub for the south of the borough.

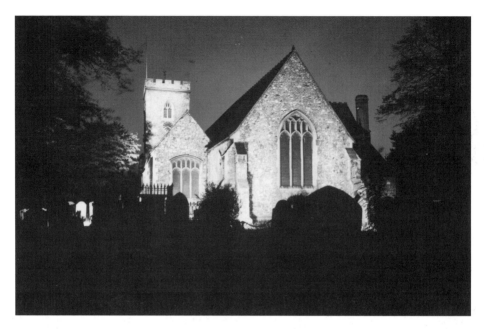

St Mary's, the parish church of Willesden, illuminated at night in the 1950s. It is possible that a wooden Anglo-Saxon church existed before the present building. The font here dates from the mid-twelfth century. The Dean and Chapter of St Paul's were responsible for the upkeep of the chancel. Local historian F.A. Wood believed that the old Norman church helped to form the chancel of the enlarged new church when it underwent alteration in the first half of the thirteenth century. A tower was also added at that time. (9797)

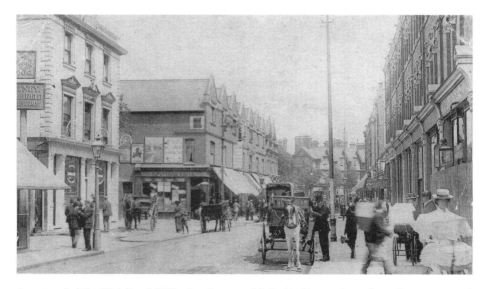

A postcard of the High Road, Willesden Green, published by Reeves. It predates the extension of trams from Willesden Green to Harlesden in 1907. The pub on the left is the Spotted Dog, which existed by 1762 and was rebuilt in about 1881. The pub closed in 2007 and is being turned into flats, with a preserved façade. (8118)

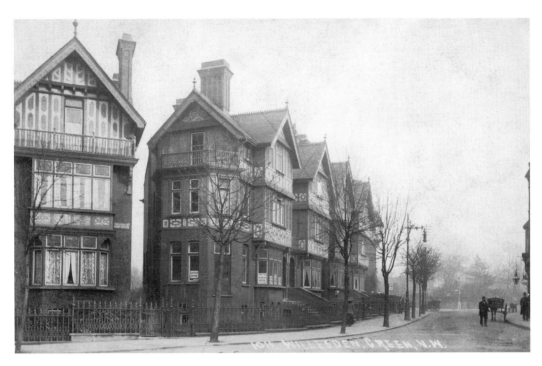

Park Houses, Willesden High Road, Willesden Green, after 1901. The name 'WILLESDEN PARK HOUSES' can be seen on the left-hand building. These buildings are first listed in *Kelly's Directory* in 1896 and this image may date from not long afterwards, as the central building includes an estate office advertising 'HOUSES & FLATS'. However, British postcards with a space for the message on the back, allowing a picture to occupy the whole of the front, cannot date from before 1902, and the street lighting looks electric, which, in Willesden, again cannot predate 1902. The ground floors of these buildings are now shops. (1472)

Willesden Working Men's Club, 202 Villiers Road, post-1914. As the plaque reading 'GLADSTONE HALL' suggests, this building was originally connected with Liberal and Radical politics. It is listed as the Willesden Radical Club & Institute Society Limited in the 1897 *Kelly's Directory*. It did not appear in the 1895 publication. The secretary in 1897 was Walter Wilkie. On 4 April 1910 an alleged breach of the Licensing Act by the club (apparently regarding Sunday opening) was mentioned in the House of Commons! The venue became Willesden Working Men's Club in about 1914. (9063)

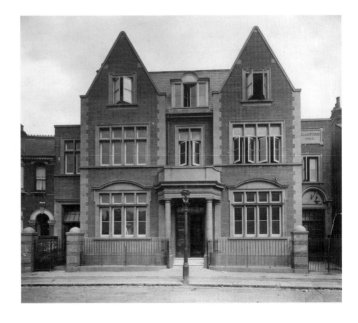

The Isolation (or 'Fever') Hospital, in an HRM Series postcard, pre-1914. This hospital opened in 1894 in a suitably isolated and uninhabited area to the extreme south-west of Willesden. The only other nearby landmark was a sewage farm, which had been there since 1886. In the 1950s the hospital became a specialist centre for the treatment of bulbar poliomyelitis, but it was closed in 1986 and has since been demolished. (1290)

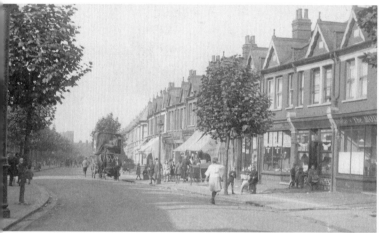

Chapter Road pre-1914, with shops, pedestrians, prams and a large cart with a canvas tilt all in evidence. More recently, Chapter Road was the location of the Grunwick photo-processing factory, where a memorable dispute erupted in 1976. This is illustrated in chapter 11. The fact that this street is referred to in two sections of this book is a salutary reminder that the borders of the various districts within Brent are nebulous. (1476)

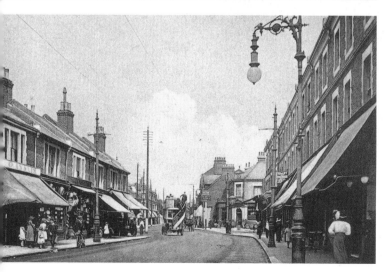

Church Road, post-1906. At this time Church Road was the main road to Harlesden, used by both buses and, from 1907, trams. Although still used by buses, it is now bypassed by most road traffic. The pub in the left middle-distance is the White Horse, serving local Michell & Aldous beer, brewed in Kilburn. (7977)

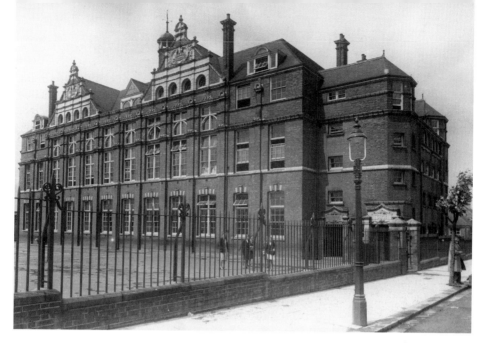

Pound Lane School, photographed by J.W. Debenham, probably 1930s. The school opened in 1903. In 1927 the school was reorganised as the selective Willesden Central School, but became a secondary modern under the 1944 Education Act. In 1967 it was amalgamated with Willesden County School, creating Willesden High School. The Pound Lane buildings were used as an annexe. Willesden High School became Capital City Academy in 2003. Pound Lane was named after a brick animal pound demolished in 1895. (751)

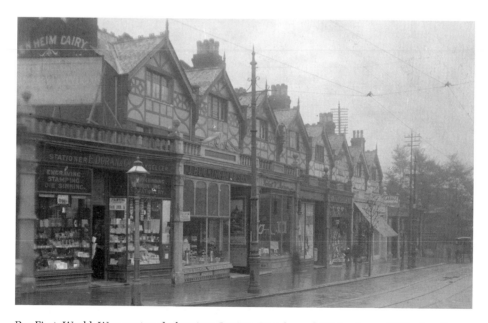

Pre-First World War postcard showing Station Parade and Walm Lane, Willesden Green, on a wet day. The coming of the Metropolitan Railway in 1879 led to the construction of houses by the United Land Company which were thought by some observers to have ruined the character of the whole district. The same could certainly not be said of this attractive parade of shops. (1443)

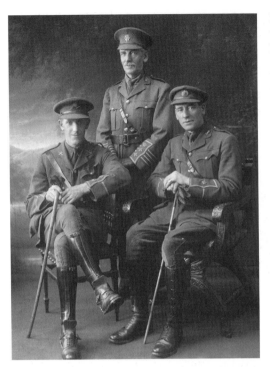

Lt-Col Charles Pinkham (1853–1938), standing, with his sons Charles and Archie, during the First World War. The son of a Devon agricultural labourer, Charles Pinkham became an important builder and local politician in the Willesden area. He was five times chairman of Willesden Urban District Council, and Unionist MP for the new Willesden West constituency from 1918 to 1922. He also served on Middlesex County Council, the Metropolitan Water Board and as a magistrate. During the First World War, Pinkham assisted in raising a volunteer battalion (essentially a sort of Home Guard), of which he was honorary colonel. After the war he became Deputy Lieutenant, and later High Sheriff, of Middlesex. Note the variety of headgear, the result of officers buying their own uniforms. (9704)

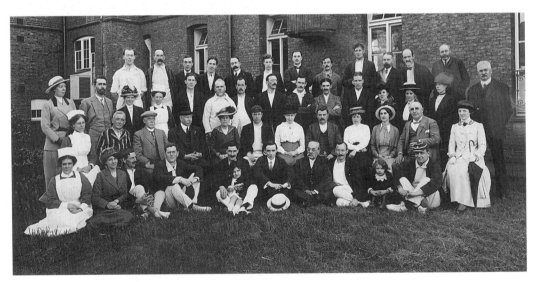

Willesden Board of Guardians cricket match, probably at Park Royal, 1922. The parish of Willesden was originally part of the Hendon Poor Law Union, which had been formed in 1835. Since the majority of the inmates of the overcrowded Hendon workhouse came from Willesden, a local campaign was mounted to create a new Willesden workhouse. In 1896, the Local Government Board ruled that Willesden should operate separately from the Hendon Union and become an independent Poor Law District. This took effect on 13 August 1896. Poor relief was administered by a new Board of Guardians, with twenty-one members, three each from the seven wards in the parish. Here, it could be said, the Board of Guardians are showing their lighter side in enjoying a spot of recreation. (9796)

Fred Ward pictured with a Hazel Hand Laundry van in 1923. The Hazel Laundry traded from 100 Chaplin Road from 1918 to 1963. At this time there were fifty-three factory laundries and twenty-three domestic laundries in Willesden. In 1919, fifteen laundries each employed more than forty women. The *Willesden Chronicle* in 1888 attributed the growth in the industry to 'the salubrity of the upland air from Dollis Hill.' The area's close proximity to London and the need for local women to earn good wages to supplement the seasonal work of their farming and brick-making husbands also contributed. (8952)

Ronald Herbert (b. 1921) walking east down the north side of Willesden High Road, just east of the Spotted Dog, in 1935. The photograph was taken by a street photographer. Mr Herbert, whose father was a labourer, lived with his parents in Stevens Cottages, behind the Spotted Dog. (9414)

Sidmouth Road, probably in the late 1930s. These blocks of flats had been built in the early 1930s. The elegant block to the left is Clarendon Court. (1574)

Mavis Tate (1893–1947), Conservative MP for West Willesden, 1931. Born Maybird Constance Hogg, Tate was MP for West Willesden from 1931 to 1935, and then for Frome in Somerset from 1935 to 1945. According to the *Biographical Dictionary of British Feminists*, 'for the short period she was in Parliament she was one of its most active feminists,' but she also joined the anti-Semitic Right Club in 1939. There is, however, no evidence of her ever engaging in right-wing extremism. Indeed she claimed to be the only MP to have got two people out of a Nazi concentration camp. She had a nervous breakdown in 1940, but recovered and chaired two committees dealing with women's rights and equal pay. In 1945 she was part of a group of MPs who visited the recently liberated Buchenwald concentration camp, writing about her experiences in the *Spectator*. A viral illness she contracted on the visit probably contributed to her suicide. (9705)

Hawthorn Road, Willesden Green, 24 September 1940. Civil Defence workers engaged in rescue activities after a bombing raid, in this case saving a pot plant and some ceramics. (Fox Photos/ Hulton Archive/Getty Images)

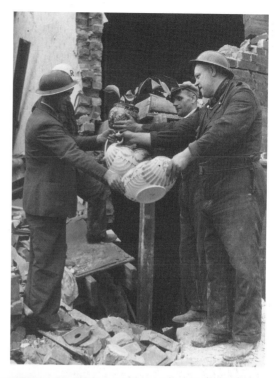

The interior of St Mary's Church, Willesden, November 1950, showing its arrangement before later alterations. St Mary's had already undergone major restoration work in 1872, which revealed the oldest parts of the church (with the exception of the font) to be the south arcade pillars dating from the thirteenth century. Further restoration work took place in 1999, in which English Heritage was involved. The absence of stained glass in the central portion of the east window is due to war damage. (9794)

Willesden Synagogue, *c.* 1960. Jewish immigration to the area started in the 1870s, with people moving into the suburbs from the East End, or directly from Eastern Europe. This synagogue was established in 1934 and a building constructed on Heathfield Road in about 1939. In 1959 two houses in Brondesbury Park were demolished and the extension in the photograph, consisting of the Max Faiman Hall and facilities for children, was built to designs by architects Shaw and Lloyd. When Brondesbury Synagogue closed in 1974, many of its congregation joined this synagogue, which was renamed Willesden and Brondesbury Synagogue. (8777)

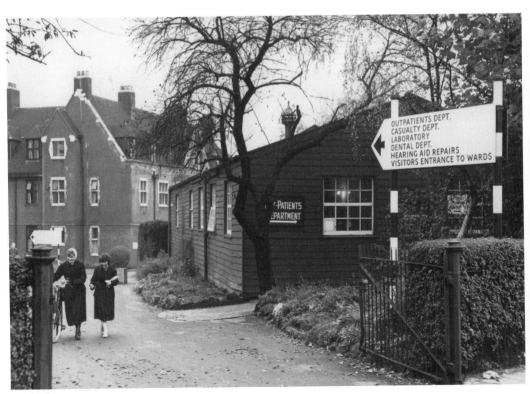

An entrance to Willesden General Hospital, late 1960. This photograph, which was published in the *Willesden Chronicle* for 4 November 1960, shows the wooden huts used by the outpatients department. It had just been announced that these were to be replaced by a two-storey brick structure. The huts had been built to accommodate wounded soldiers during the First World War. (9848)

A day trip to Dymchurch by residents of Frontenac, Donnington Road, 1961. Frontenac is a block of flats named after a house that used to occupy the site. There are two communes called Frontenac in France, but the name is mostly associated with Canada, because Louis de Buade, Comte de Frontenac et Palluau (1622–98), was Governor-General of New France in the late seventeenth century. George Samuel Baker, who named the house Frontenac in about 1901, had been born in Murray, Ontario, in 1860. His father, Joseph Baker, seems to have lived next door, at Donnington. (8323)

Dr Patrick Vincent Charles Joseph Solomon, the High Commissioner of Trinidad & Tobago from 1971 to 1976, unveils a picture of Learie Constantine, presumably at the Learie Constantine Centre, Dudden Hill Lane. Trinidadian Sir Learie Nicholas Constantine (1902–71) had been newly independent Trinidad & Tobago's first High Commissioner, in 1962. A famous cricketer, Constantine had been part of the winning West Indies side in the 1934–5 Test series. After his retirement he became a BBC commentator, and later a member of its governing body. During the Second World War, he worked for the Ministry of Labour. His varied pursuits were recognised with an MBE in 1947. He was made a knight in the same year and concluded a distinguished career with a new role as the Rector of St Andrew's University. He lived in Kendal Court, on Shoot Up Hill, just outside Brent. (9795)

ACKNOWLEDGEMENTS

We are indebted to the following, who have generously offered their support to this project: Robert Barker, Barnet Archives, Kenneth Barrès-Baker, Anthony Barthorpe, Robert Brown (Beverley Reference Library), Murray Bumstead, Joe Carr (Brent Museum), Dilwyn Chambers, Marianne Colloms, Carolyne Darley, Diageo, Holly Fairhall, Getty Images, Jim Gledhill (Museum of London), Philip Grant, Ronald Herbert, Geoffrey Hewlett, F. Howard, Kate Jarman, Liz Jenkins (English Heritage), Imperial War Museum, Richard Leatherdale (The History Press), Leicester Record Office, Nick Lera, Kirsty McCullagh, Sue McKenzie, Mohammad Mahboubi, Alan Minchin, National Portrait Gallery, Dr David Neave, Rachel Oliver, Brian Parsons, Eibhlin Roche (Guinness Archive), Angela Rumsey, Len Snow, Gillian Spry, Jack Stasiak, Michelle Tilling (The History Press), Tony Travis, Cliff Wadsworth, Dick Weindling, Wembley History Society, Willesden Local History Society.

Mr J.T. Gillett, Willesden's Borough Librarian, using 'the new Docustat coin-operated copying camera' at Willesden Central Library, March 1964. The 20 March edition of the *Willesden Chronicle* explained that the photocopier, one of only fifty in England, 'will save many people hours of unnecessary and tedious work.' The 2s per copy cost was over half the price of a paperback book! Despite this, and the fact that the copies seem to have come out as negatives, it was used 100 times in the first week.

(8695)